Manga
Your World

A RotoVision book

Published in 2016 by Search Press Ltd.
Wellwood, North Farm Road
Tunbridge Wells
Kent, TN2 3DR

This book is produced by
RotoVision SA
Sheridan House, 114 Western Road
Hove, BN3 1DD

Publisher: Mark Searle
Editorial Director: Isheeta Mustafi
Commissioning Editor: Alison Morris
Editor: Angela Koo
Junior Editor: Abbie Sharman
Art Direction: Michelle Rowlandson
Design: JC Lanaway
Design Concept: Agata Rybicka
Cover Design: Agata Rybicka

ISBN: 978-1-78221-400-7
Printed and bound in China
10 9 8 7 6 5 4 3 2 1

Image credits
Front cover: Illustrations by Sonia Leong; (top)
iStock; (bottom right) Tamsin Richardson.

Back cover and flaps: Illustrations by Sonia Leong.

Manga
Your World

Sonia Leong

SEARCH PRESS

CONTENTS

Introduction	6
Techniques	**8**
Finishes and styles	10
Drawing basics	14
From photo to finish	18
Creating a storyboard	22

1: SHOUNEN

Shounen overview	28
Drawing Shounen-style characters	30
Draw yourself as a fantasy hero	34
Draw yourself as a mecha pilot	36
Draw custom sports equipment	38
Draw yourself as a sports star	40
Draw a comic strip: A night at the mall	42
Shounen figure templates	44

2: SHOUJO

Shoujo overview	48
Drawing Shoujo-style characters	50
Draw yourself as a Harajuku girl	54
Draw yourself in a Japanese school uniform	56
Draw yourself on a date	58
Draw a comic strip: Sleepover	60
Shoujo figure templates	62

3: SEINEN

Seinen overview	66
Drawing Seinen-style characters	68
Draw yourself as a samurai	70
Draw yourself with supernatural powers	72
Draw a sexy crush	74
Draw a drift racing car	76
Draw a comic strip: Demon stranger versus hunter	78
Seinen figure templates	82

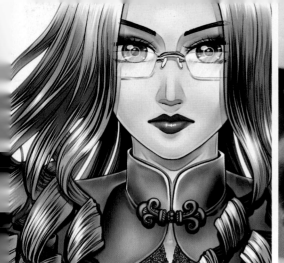
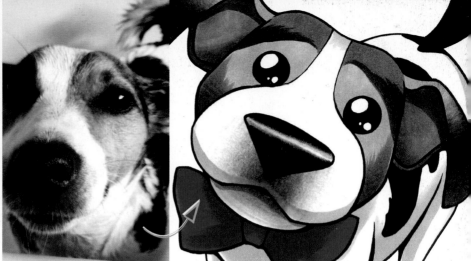

4: JOSEI

Josei overview	86
Drawing Josei-style characters	88
Draw a high-fashion self-portrait	90
Draw yourself as a geisha	94
Draw yourself as a fairy-tale princess	96
Draw a comic strip: On-off relationship	98
Josei figure templates	100

5: KODOMO

Kodomo overview	104
Drawing Kodomo-style characters	106
Draw your cousins as adventurers	108
Draw your little brother as a robot	110
Draw a magical bus	112
Draw your friendly dog	114
Draw a comic strip: Dropping a birthday cake	118
Kodomo figure templates	120

6: CHIBI

Chibi overview	124
Drawing Chibi-style characters	126
Draw a cute self-portrait	128
Drawing exaggerated facial expressions	130
Draw yourself and a friend with animal ears	132
Draw your food in a cute style	136
Draw a comic strip: Looking after a small child	138
Chibi figure templates	140

Index	142
Picture credits	144

INTRODUCTION

Manga is extremely popular around the world, enjoyed and emulated by many fans even outside its home country of Japan. It comes in so many styles, with such a wide selection of themes and storylines, that you're sure to find a series that suits you perfectly.

Once you start reading and admiring the artwork, you will want to start drawing manga versions of yourself and your friends – that's fantastic! But, it can be harder than it looks. It seems simple and clean, but the beauty of manga lies in the artist's skill in expressing a variety of characters and their emotions with just a few lines.

When faced with this dilemma, many of us look to our favourite manga to try to copy what that artist does. This is only effective if you make an effort to analyse the techniques. Why did she draw the side of the face like that? What happens when she draws a younger character? Even so, this is just one artist . . . what about others? And what happens if an artist changes his or her style because a publisher asks them to? You have to do your research.

It is a common misconception that all manga looks the same – big eyes, small noses/mouths and big hair. Manga is simply a medium through which to tell stories. The stories you choose to tell, and the way that you tell them, can vary hugely. Of course, fashions come

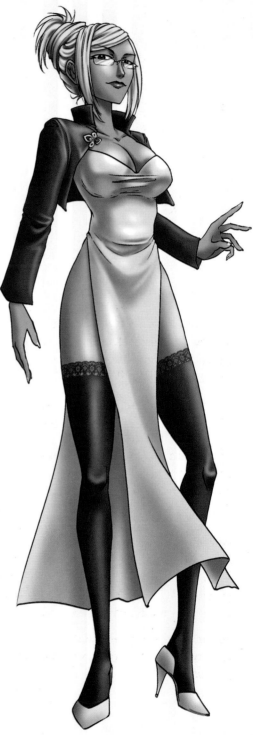

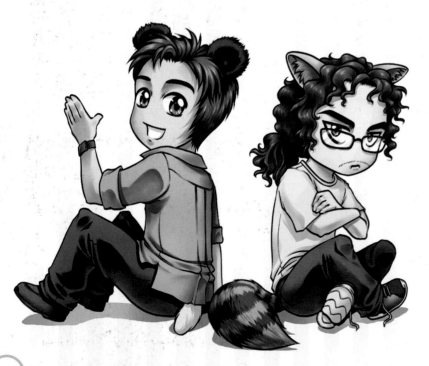

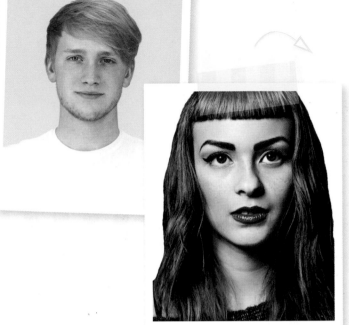

and go, so whatever is the most popular gets exported and becomes the new norm. But, in Japan, there have always been comics aimed at very different audiences, from young children looking for cute, educational manga, to bored businessmen wanting well-researched science fiction.

The chapters of this book introduce the most popular styles, complete with several exercises for each, converting real-life photos into manga. Take inspiration from photos for poses, hairstyles and clothing, but if you want to create original character designs, don't copy the photos too rigidly or you'll hold yourself back. Manga is meant to be larger than life! Each chapter then concludes with a more challenging comic tutorial, broken down into steps to walk you through the choices a professional makes. This is the key to success with all of the exercises – everything is broken down into stages, so just work at your own pace. All of the figures in each chapter are provided as simple templates, too, which you can trace if it all feels a bit difficult.

So, why not get started? With so many examples and styles to choose from, you really can manga your world!

TECHNIQUES

スタイル

Manga illustrations come in all shapes, sizes and styles, as do the tools and techniques used to create them. What works for one style may not be good for another, so experiment with the options outlined in this section.

FINISHES AND STYLES

Manga artwork comes in many different drawing styles, depending on the artist and the intended audience. But, just like other forms of artwork, the media used and the way it is finished varies hugely. The following pages provide an introduction to some of the most popular media and techniques.

Traditional approaches

Nothing beats an original piece of artwork that you can hold in your hands. Manga has been created with traditional media for decades – some have become almost synonymous with the format (e.g., screen-toned comic pages and alcohol-based marker illustrations). If you want to get your hands dirty, try some of these!

Pencils

This is one of the easiest ways to get started. For drafts, a basic HB writing pencil or mechanical pencil is fine – you're only laying down guidelines to ink over, and these get removed later. For finished work, use artists' drawing pencils with softer, larger leads. Hold your pencil upright and close to the tip for fine details, and hold it sideways and close to the end for long lines and shading. You can use your fingers to smudge, but avoid unwanted smudges by placing paper between your hand and the drawing! Using an eraser for highlights is very effective, too.

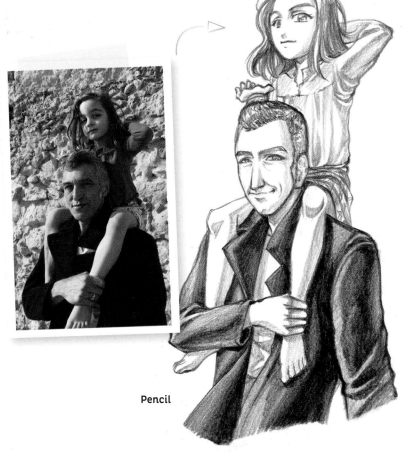

Pencil

Coloured pencil

Coloured pencils

These are another accessible, forgiving medium for beginners, but your choice of paper and pencil can make a big difference. A fairly smooth cartridge paper with a small grain will give just enough texture for a charming effect without losing the delicacy of an artwork. The pencil lead should be saturated with colour, and its texture should be smooth, quite soft and waxy. Cheaper pencils can be brittle and grainy, leaving hard, random spots of colour. Use coloured pencils to do your outlines as well; black inks or normal graphite pencils will make your drawings look flat and amateurish. Layer colours on top of each other for more depth and vibrancy.

Pen and ink

Manga is predominantly a black-and-white medium. The high contrast of black against white, and the choices made by artists as to which lines and facial features to focus on, really come into play. The challenge with pen and ink is to ensure that your artwork feels lively and has depth. Do this by varying your line weight from thick to thin, finishing the ends with tapered points, and contrasting areas of high, sharp detail with areas of bold, black fills. Use dip pens, brushes and fineliners in various sizes, and add texture and shading by using semi-dry brushes and rougher paper.

Ink and screentone

This is the classic look of real manga – a technique developed by artists needing to produce quality work quickly. Outlines and some black fills are done in pen and ink, then screentone is cut out from sticky sheets and stuck on to the lines to add shading and special effects without having to ink everything from scratch.

Screentone is a way of rendering shadows as dots, lines and other patterns that a printing press reproduces very well. If left to its own devices, a printer will convert greys and soft shadows into black dots with no variation in dot size, shape or density; there may be soft, fuzzy outlines around the edges of lines and shadows, as well as inconsistencies from one press to another. Screentone ensures that final printed pieces come out just as intended, in crisp black and white.

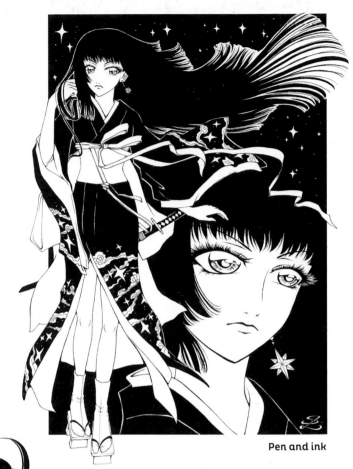

Pen and ink

RIGHT: *A close-up of screentone dot patterns laid on top of inked lines. The technique is roughly the same, whether done traditionally or digitally – it's all about sticking your chosen patterns on top.*

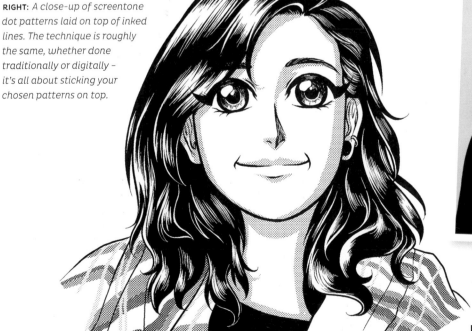

Ink and screentone

Markers

Markers are transparent, so detailed line art shows through. You can lay down several layers to build up colour, depth and texture. Or, you can create flat fills, completely smooth blends and gradients if you work enough solvent into the paper, but you must work fast! Manga artists love markers because it takes under a minute for the solvent to evaporate, allowing you to keep working and layering more shadows on top of any fills. Colours remain consistent, too – no need to pre-mix a palette, or match an exact shade. Most markers have twin tips (a large chisel and a fine tip) or a flexible brush tip option to create a variety of marks. A good 20-colour set can be pricey, so purchase subtle shades first: pale pastels, tinted greys and smoky, desaturated darks.

Watercolours

Although not as quick and convenient as markers, these produce a similar finish at a fraction of the cost. Cheap paints can be grainy, so invest in a high-quality set of tubs in a few key colours, then mix these to get other shades. Buy the smoothest paper you can afford – manga has lots of close-ups and fine details that can get lost in rougher textures. There are lots of watercolour techniques, but the key points are: keep your washes translucent; preserve the white of the paper for general highlights, using masking fluid if necessary; avoid white paint unless dotting on opaque highlights at the end; and work on wet paper for softer blends and shading, letting it dry if you want distinct, crisp shadows and brushstrokes.

Digital approaches

Today, almost all artwork is digitised at some point, whether it's for online publicity or because certain styles are achieved much faster this way. Ultimately, though, digital tools should never be considered a replacement for actual skills. Using digital tools requires just as much practice as traditional media if you want to get the most out of them.

Emulating traditional media

Some software allows you to create artwork that looks surprisingly similar to traditional pieces. You will need a graphics tablet, or a tablet computer, and a pen stylus with a good tilt, angle and sensitivity to pressure. This means that your software can detect the movements of your pen, as if you were drawing naturally, which translates through to the strokes you make. Your software has to have brushes with settings that you can adjust to match real-life equivalents. For example, a dip pen will make thicker lines if you press harder, so a digital pen should do the same. A pencil makes darker lines if you apply pressure, so a digital pencil should, too. Texture can be linked to either the brush or the canvas you draw on. Not all software is the same, so try out free demos to see which suits your style. The example shown below demonstrates the addition of digital screentone on top of the lines, just as you would do by hand.

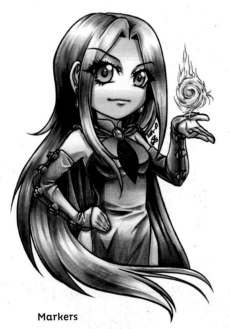

Markers

Watercolour

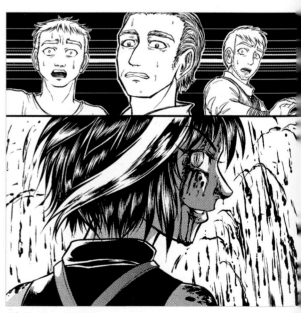

Digital screentone

Cel art

Airbrush

Digital airbrushing is clean and simple to control – you can select areas to shade, mask off sections easily, keep things on separate layers if you change your mind, and so on. Like cel art, you start with flats or basic gradients before adding soft shadows and highlights on top. Most manga illustrations don't just stick to soft blurs; the best have a few sharper shadows mixed in, too.

Cel art

If there is one style suited to digital work, it is cel art. Originally created with acrylics on the back of clear cel sheets with black line art, this style was mostly used for animation. Painting cels is messy, so when computers advanced enough in the 1990s to allow it to be done digitally, artists leapt on the innovation. Truly flat fills, needle-sharp shadows and clean, thin lines became far more achievable. Cel art's beauty lies in its simplicity. Choosing the right amount of detail to go into with the shadows is crucial – be bold and put large areas in shadow if you need to. Only add extra dark shadows or extra highlights if you are dealing with a very reflective surface.

Airbrush

DRAWING BASICS

Although this book is all about using photos as your reference, you may want to try a different pose or draw more of the body than what is pictured. Here are some basic guidelines to help you recreate your photo subjects accurately.

Faces

Despite subtle variations, there are shapes and proportions that are common to most faces. The following guidelines will help you place features correctly. Then, simply add detail as required until you have a close resemblance to your photo subject.

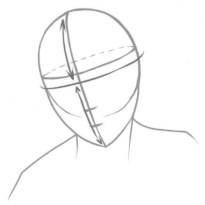

Positioning features

Heads consist of a sphere, with the chin hanging below this, forming an egg shape. The eyebrows lie halfway down the sphere. The nose tip is halfway between the eyebrows and the chin. The mouth is halfway between the nose and the chin, and the eyes are halfway down the entire head (shown in pink).

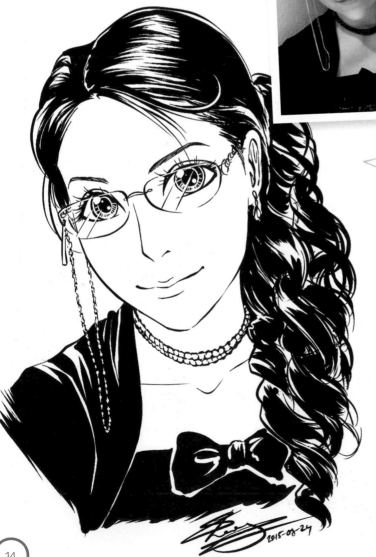

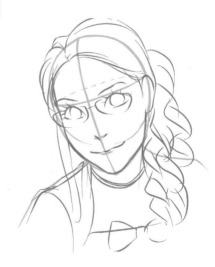

Making a face recognisable

A line drawn down the centre of the face helps keep features symmetrical. Make someone recognisable by copying the eye shape, how far apart the eyes are set, the length of the nose, the nostril shape, how high the mouth is, and the shape of the cheeks and the jawline. If you draw in a highly stylised way, at least try to match the hairstyle.

Figures

Drawing figures takes skill, particularly if you're trying out a pose that differs from what's in your photo. But, as with faces, there are a few simple tricks you can use!

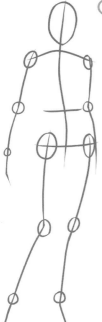

1 Start by getting a feel for your subject's spine and weight placement. This is known as the 'action line'. Draw an oval for the head, then quickly draw a line down through the spine. This allows you to shift the shoulders and hips into the correct position and place the legs underneath the body to hold its weight. Draw circles at the key joint areas to remind yourself of where things bend.

2 If you can't see the whole body in the photo, you will need to make up the correct proportions. Think of bodies in terms of head lengths – how many heads make up your character? Above seven is tall; below seven is petite. Then, get your leg length right: legs are roughly half the overall height of a figure.

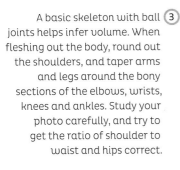

A basic skeleton with ball **3** joints helps infer volume. When fleshing out the body, round out the shoulders, and taper arms and legs around the bony sections of the elbows, wrists, knees and ankles. Study your photo carefully, and try to get the ratio of shoulder to waist and hips correct.

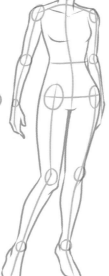

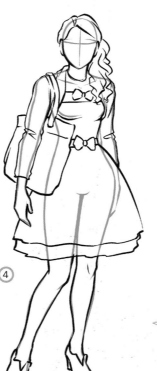

Draw your characters in the **4** nude first, then place the clothing on top. That way, you will get the volume correct and be able to figure out where garments will crease and drape.

Children

The proportions of a child are quite different to those of an adult – their heads are relatively larger, as their bodies haven't had time to stretch yet! For children, you'll find that anything under five heads works.

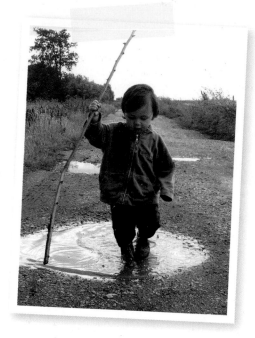

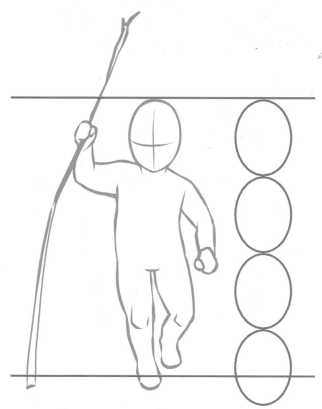

① This two-year-old toddler is just three-and-a-half heads tall. Also, note that his body seems quite long, but his limbs are quite short.

Drawing notes

Remember that in addition to being bigger, children's heads are different in other ways, too, with larger eyes, smaller noses and mouths, and rounder faces.

Draw clothes over the nude ② rough. This can be even more important when drawing children – they often wear things that appear oversized, so it's key to get the draping right.

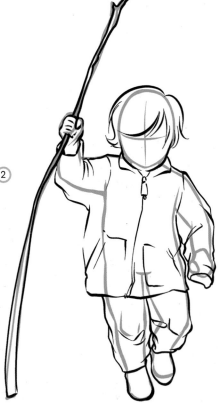

Hands

Hands have a complicated structure, but it's important to get them right because we use them so much. Understand their bone structure, and study real-life examples so that you put them into realistic poses.

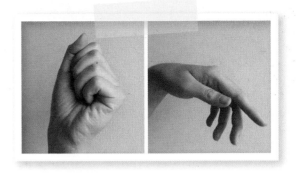

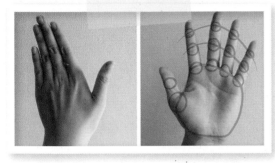

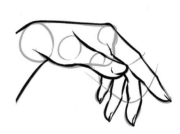

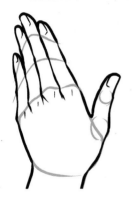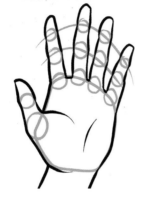

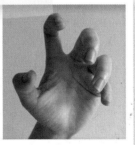

Different poses

When dealing with curled fingers or bent wrists, try drawing more circles on the joints to remind yourself to add bumps in the final drawing. Use lines across knuckles and finger joints to keep them aligned.

Fingers and thumbs

The thumb meets the palm lower than the other fingers. The middle finger is the longest – roughly the length of the palm. There are knuckles where all the fingers join the palm. The thumb then has one joint, while the fingers have two. Hint at fingernails if the hand is facing away from you, or indicate that the palm is facing you by drawing a couple of lines on the mounds.

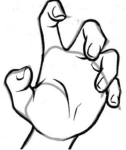

Tricky shapes

For challenging poses, draw the palm shape first, then sketch the top contour lines of the fingers before adding volume.

FROM PHOTO TO FINISH

Transforming a photo into manga may seem daunting, but the process is always broken down into stages. You just need time and patience. Templates for all the figures shown are given at the end of each chapter, too, so tracing these will give you a head start if you need it!

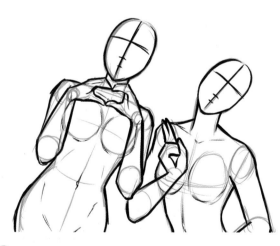

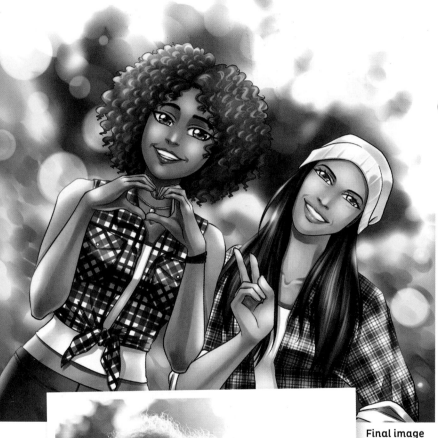

Final image

1. Let's take this photo of two female friends as our guide. Start by laying down some shapes to help you build up the figures. Ovals and circles are useful for fleshing out limbs and reminding you where curves go. For example, the shoulders are rounded out, as is the base of the forearm. Apply the relative proportions covered in 'Drawing Basics' on the previous pages to ensure everything is the right length.

2. Finalise your figures by drawing the outlines of the bodies over the guideline shapes; let them dictate where the lines of bone and muscle go, then smooth over and connect the shapes. Always start with a nude figure to get your foundation right.

3 Remove your coloured guidelines and gradually add in the details of the faces. Position the eyes, nose and mouth correctly over the cross on each head, then start working on the hair and finger joints.

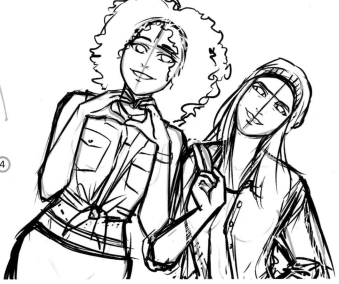

Keep adding in more details until you feel that 4 you will have enough information to ink accurately over the top. Drawing clothes on top of nude figures makes things much easier – you can then gauge where the fabric will drape, hang and crease.

5 This step will take time! Add a new sheet of paper on top of your sketch (or a new layer if you are working digitally) and trace over your rough lines with a much thinner pen. Lift your pen up and away as you finish each stroke for an elegant finish. Varying line widths will also give your drawing a more 3D appearance. Remove your draft lines and make any corrections.

Digital painting makes it very easy to colour 6 underneath lines and clean up any mistakes. Aside from that, it's similar to painting traditionally – try to work from the back to the front. It is much easier to paint over the top of something than to paint something in front, then try to colour stuff behind it! So, add a layer underneath your inked lines, then roughly lay down the skin in a medium brown.

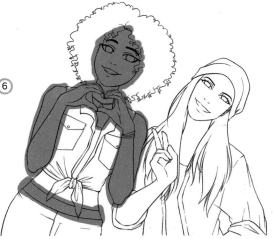

PRO TIP!
Hair types

Hair presents several challenges at once, as it comes in many colours, styles and textures. It also has quite a shiny surface and is made up of thousands of tiny strands. To depict it in manga, we simplify it to outlines, then in the colouring and shading process we use brushstrokes to hint at the texture. Straight hair is easiest – you simply draw multiple strokes of highlights and shadows up and down along the clumps. Curly hair is harder. Here, your strokes should be in parallel waves, with highlights at the convex, top part of each curl, and shadows on the underside of each curl (see also page 55, Pro Tip).

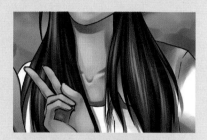

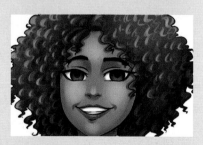

Add basic shadows and highlights ⑦ over the skin slowly. See, too, how the lighting in the photograph has been taken into account? It is quite soft and diffuse, so most of the shadows are soft too, with sharper shadows in the features and areas that are strongly defined (the underside of the nose, the eye sockets, neck, hem of the shirt, collar over the breastbone).

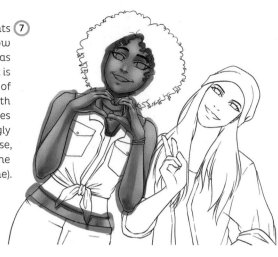

⑧ Keep adding flats and shading to each area in this way. Add them in on top of each other where you can; skin usually comes first, then clothes, then hair (although the hat comes last!). When you've finished, erase any spillover outside the lines. When working digitally, the Magic Wand tool can help you to select areas defined by your lines and help speed up the cleaning.

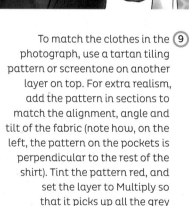

To match the clothes in the ⑨ photograph, use a tartan tiling pattern or screentone on another layer on top. For extra realism, add the pattern in sections to match the alignment, angle and tilt of the fabric (note how, on the left, the pattern on the pockets is perpendicular to the rest of the shirt). Tint the pattern red, and set the layer to Multiply so that it picks up all the grey shading underneath.

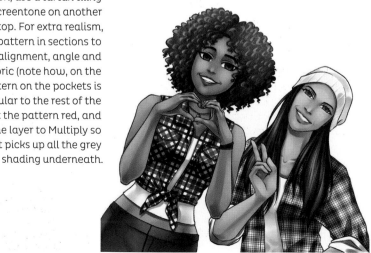

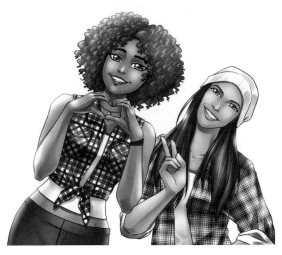

(10) The photograph has a soft, glowing feel, with sunny backlighting, so airbrush in some warm, bright yellow highlights, particularly around the edges. Add a few sharp white highlights to the eyes and lips to give them sparkle.

(11) If working digitally, you can do this at the start or at the finish, as you can add and position layers wherever you wish. But if you are working traditionally, this definitely comes first! Choose muted greens, browns and warm greys that are harmonious with the colours used so far. Use plenty of soft dabs to lay down the darker leaves of the tall trees in the background, then on top, paint the green bushes and shrubs in front. Blend in whites at the edges to help them fade out.

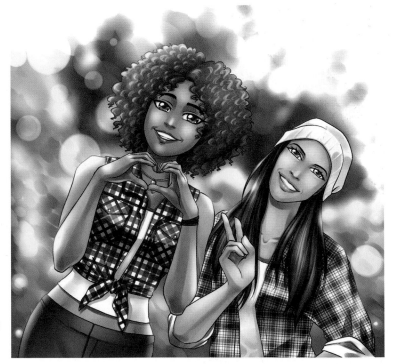

(12) Airbrush in soft, round yellow highlights at the white edges and the tops of the green bushes for a backlit, magical sunshine effect. Change your brush size frequently to add interest.

Now, combine (13) everything for the full effect!

CREATING A STORYBOARD

It's easy for manga newcomers to get distracted by pretty characters and think that's all it is, but they would be wrong. *Manga* is the Japanese word for 'comic'. It is an entire format of telling stories, utilising specific techniques that have grown out of the way comics are consumed and enjoyed in Japan. A lot of thought goes into storyboarding – the way panels are arranged on the page and what is drawn in and around them.

Reading direction and order

Japanese traditionally reads from top to bottom and right to left, so manga typically reads this way. However, manga has now been translated into many languages, including English. Initially, manga was flipped or rearranged so that it would read from left to right, like English, but this slowed production and increased costs. Nowadays, books are reprinted in their original format with just speech bubbles and sound effects translated, and readers are asked to read 'backward'. But, many creators also make manga in English from the start, drawing from left to right. Whatever language you publish in, once you have decided which direction you are drawing in, the rule is the same: start in one top corner, and work your way diagonally downwards to the opposite bottom corner.

ABOVE: *Japanese reading direction and panel order.*

ABOVE: *Traditionally, Japanese reads vertically, and from right to left.*

ABOVE: *English reading direction and panel order.*

Speech bubbles

Speech bubbles follow the same rules as panel order, so when writing in English, position a speech bubble near the top left corner if you want readers to look at it first; any subsequent bubbles should be further to the bottom right. Use generous bubbles and style them to match the dialogue.

Outline your bubbles
Position the bubbles in the correct order and use generous, rounded outlines.

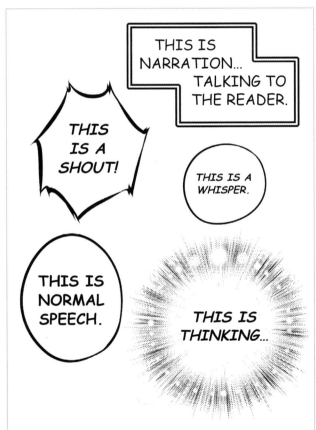

Tone of voice
Change the shape and outline style of the speech bubble to match the tone of voice. Vary the font weight for maximum effect.

RIGHT: *Although this page has many panels, it's still very easy to read as there are three distinct rows.*

Grouping panels

The first challenge any comic artist faces is breaking down the blank page into a series of panels with a clear reading order. This becomes harder with manga, where there isn't the standard convention of reading several rows of panels; they can span the page vertically or horizontally, and in various angles, sizes and shapes. The trick is to define two or three sections clearly, then break those sections down further, effectively grouping your panels. The reader then knows to read everything in one group first, before moving on to the next. Here are two techniques for this:

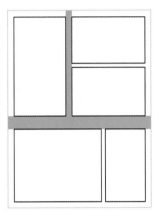 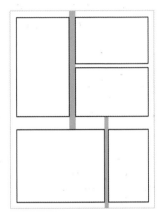

Panel gutter width
Increase the gap between two groups to highlight columns or rows.

Panel gutter placement
If panel gutters in one group do not line up with those of another group, there is more separation between them.

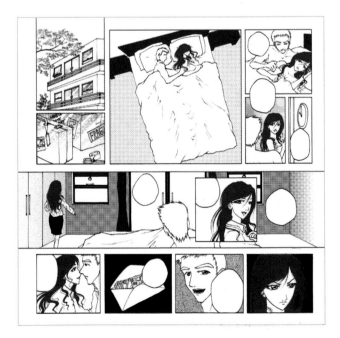

Panels and pacing

Manga is, generally, a sparse form of comic art: there aren't as many panels per page because final paper sizes are smaller, but there are many more pages to spread over. You can range from one panel across a double-page spread, to a maximum of nine panels on a page; more than that can look cramped. But, once you understand these guidelines, you can have real fun with storyboarding by controlling how fast a reader takes it all in, giving a sense of movement, creating pauses or fading out, as if you were directing a film. Here are some examples of the many effects you can achieve:

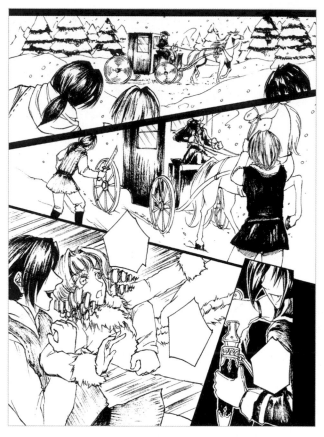

Fading in/out

A gradient fill across several blank panels, or panels that gradually reduce in size, can give a fade in/out effect. This example uses both techniques.

Diagonals

Angled lines lead the eye around the page so they give a sense of movement and chaos as a stagecoach is ambushed by bandits in the snow.

Panel size

The larger the panel, the longer the reader will look at it. Use large panels and spreads for a long camera pan, or, as here, for showcasing the important moment in which a deadly spell is unleashed in a cavern.

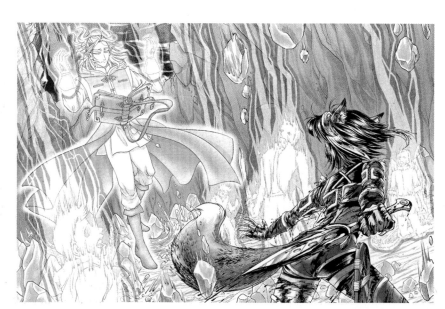

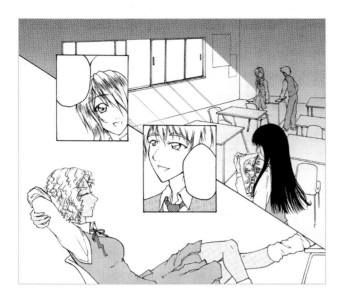

Overlapping panels
These are great for creating a sense of things happening all at the same time, or immediately after each other. Here, some students chat over each other in the classroom.

Breaking out of panels
Characters breaking out of panels take on movement, urgency and impact, as with this girl who is rushing to meet her date.

No panel gutters
A single line separating one panel from another is great for variety, but adjacent images need sufficient contrast. Here, the 'camera' pans out for the middle panel, then returns for a close-up.

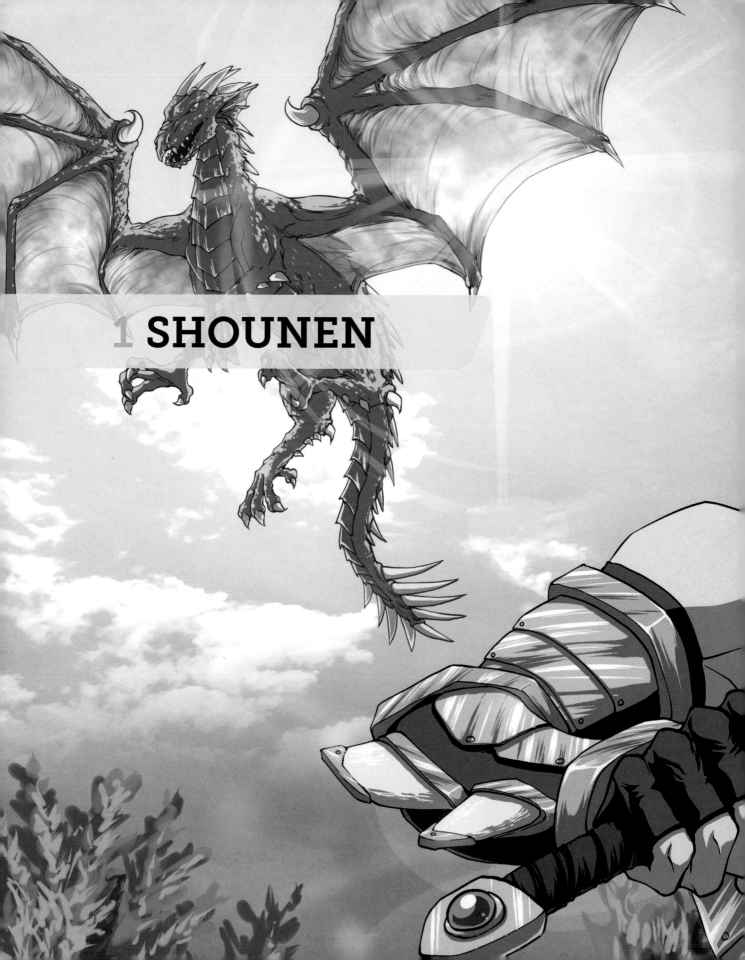

1 SHOUNEN

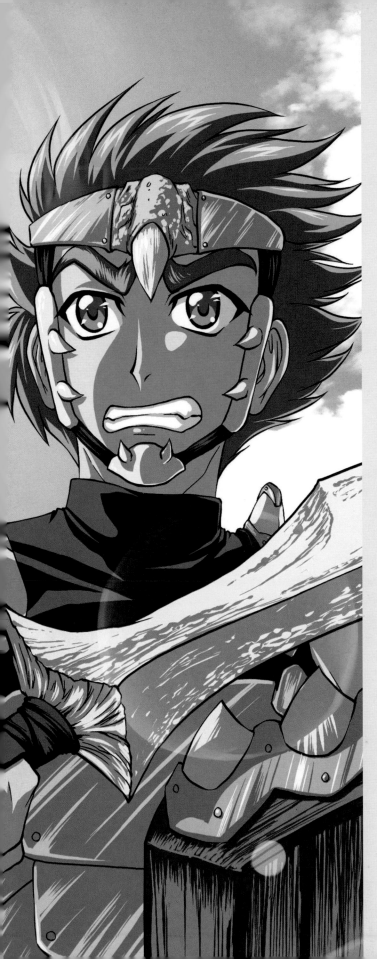

少年漫画

Shounen manga is primarily aimed at male teenagers or boys aged between 10 and 18. However, Shounen's appeal is near universal – well loved by boys and girls, and men and women alike, making up the largest share of the manga market. Whenever someone uses the word 'manga', it is almost certainly an image of a Shounen hero or heroine that comes to mind.

SHOUNEN OVERVIEW

Shounen manga covers a wide variety of settings and subject matter: sports, school, horror, fantasy – even fishing and cooking! What is common throughout all of these, though, is the way that the story follows the main protagonist's growth into becoming a master, overcoming adversity or bettering themselves, leaving a lasting impact on his or her world. There are lots of positive messages – finding inner strength, abiding by a code of conduct (even if it appears unconventional), honour and duty, compassion and sportsmanship.

The style of character artwork sets the standard here – bold, bright and stylish. Outlines are clearly defined, characters have strongly shaped facial features and bodies, and shading is quite flat and sharp. Although artwork can range from simple to detailed, many of the characters, props and environments are rendered in a fairly realistic way. Shounen artists need to know a lot about anatomy and perspective so that they can depict great fight scenes with just a few lines!

As for storyboarding, the focus here is on the physical and the technical. What is the hero doing? It is an amazing special move! How is he doing it? He's channelling energy from all of his chakra points! How is he interacting with the environment? He's superheating the air and punching a chasm straight through the mountain! Now, his rival appears. What will she do? She counters him with an elemental technique, using only 50 per cent of her strength!

This results in fast-moving pages, with lots of panels, showing multiple actions leading to a final flourish on a double-page spread. You'll see plenty of panned-out distance shots of competitors clashing and causing shockwaves around them, detailed environment shots of buildings crumbling under the strain of an epic battle, and, of course, speedlines galore.

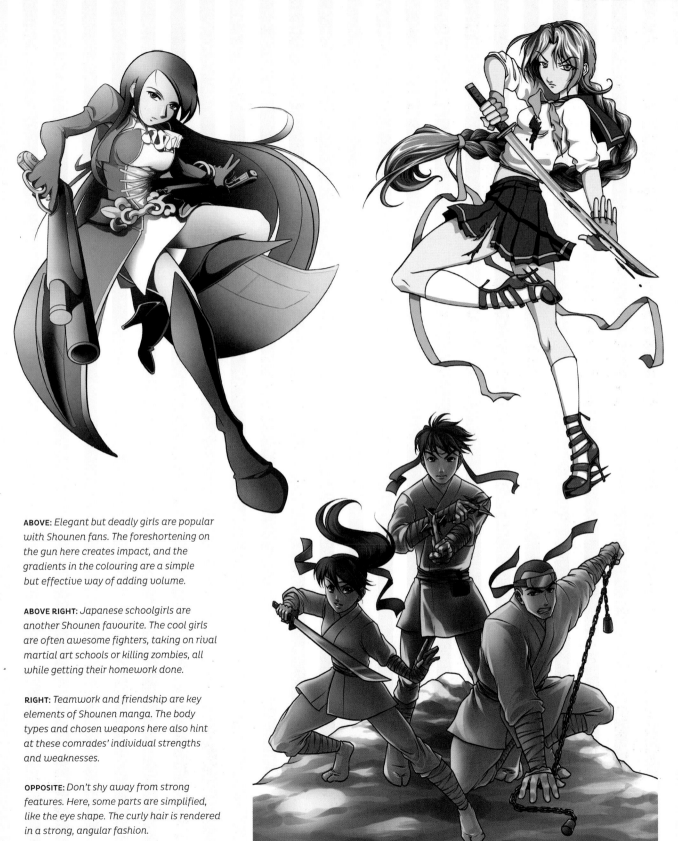

ABOVE: *Elegant but deadly girls are popular with Shounen fans. The foreshortening on the gun here creates impact, and the gradients in the colouring are a simple but effective way of adding volume.*

ABOVE RIGHT: *Japanese schoolgirls are another Shounen favourite. The cool girls are often awesome fighters, taking on rival martial art schools or killing zombies, all while getting their homework done.*

RIGHT: *Teamwork and friendship are key elements of Shounen manga. The body types and chosen weapons here also hint at these comrades' individual strengths and weaknesses.*

OPPOSITE: *Don't shy away from strong features. Here, some parts are simplified, like the eye shape. The curly hair is rendered in a strong, angular fashion.*

DRAWING SHOUNEN-STYLE CHARACTERS

Shounen artwork is vibrant, with strong outlines and colours. Although faces can be stylised, bodies are often based on realistic, if idealised, proportions. They can also be exaggerated for effect – for example, skinny and tall, or very muscular. Here are some typical characters with advice on achieving their look. (If you'd like to try these, templates for tracing are provided on pages 44–45.)

Main protagonist

Although there are some female leads in Shounen manga, the vast majority have a young male as the point-of-view character. He's normally between 12 and 16 years old, as he needs to develop and progress through the story. Personality-wise, he's never perfect – often the troublemaker, dissatisfied with the way things are, or thrust into a situation that he is not equipped to handle.

Body type

The protagonist has to be the character that readers empathise with most, so he has to be believable as a young teenage male. Aim for a lean but lightly muscled body. He may bulk up as he ages. With this in mind, he shouldn't be too tall, either; aim for roughly six to seven heads in height to make him look a little under six feet tall.

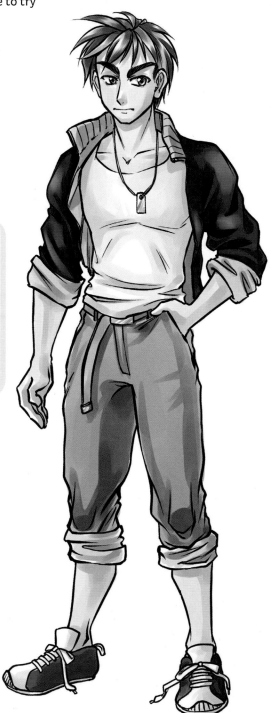

Drawing notes

Thick, bold black lines are key. Use lots of sharp angles and straight lines. For colours and shading, use a bright palette and feature strong contrasts between highlights, flats and shadows.

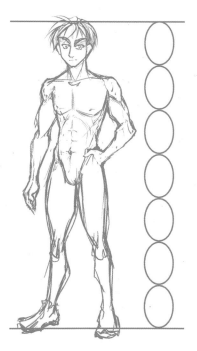

Clothing

The protagonist is a bit rebellious, or different from other guys, so his clothes should reflect that. This character has rolled up his sleeves and trousers, has loose shoelaces, a dangling belt and a dog tag. If in uniform, make sure he customises it in some way, like leaving his shirt untucked, wearing a bright vest underneath or adding an unusual belt.

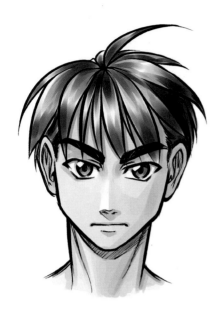

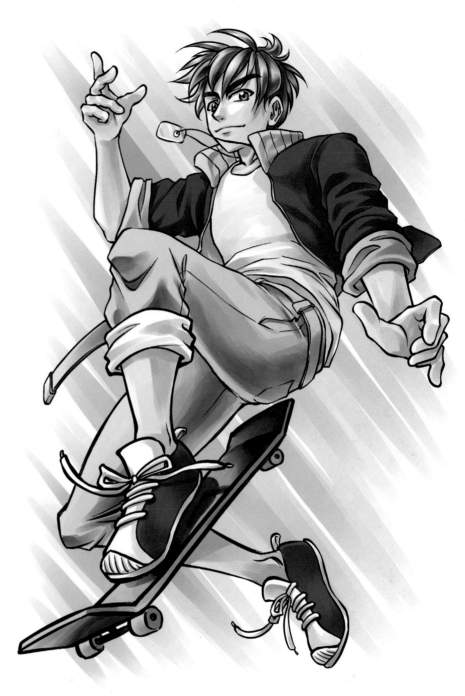

The face

Display a defiant personality in his eyes, eyebrows, mouth and jaw. Sharp angles and shapes add a hard edge, but large eyes keep him looking young. His hair is ruffled and spiky to reflect a reckless attitude.

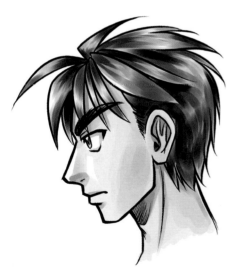

The profile

Lots of straight lines and angles in a side profile will make him look like a young man.

Pin-up pose

When drawing a pin-up shot of a Shounen hero, an active pose with a good degree of foreshortening works very well. His left foot and skateboard have been made larger here and inked with thicker lines, so that they leap out towards the reader.

Supporting characters

A good Shounen manga always has a cast of diverse supporting characters, often very distinct from each other, with contrasting body shapes and personalities. They can be sidekicks, love interests, comedy relief, rivals or mentors, but, whatever their role, make sure you give each one a strong identity.

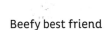

Beefy best friend
Loud, brash and fun, this guy is the rock of any Shounen team. Physically very strong due to his size, he is quick to jump to the defence of his friends, powering his way through fights. Make his face craggy and square. Draw smaller eyes and a thicker neck for bulk. Make him very tall, too – eight heads or more – and give him broad, muscular shoulders. Make sure he has plenty of dense muscle throughout. Study bodybuilders for guidance!

Love interest
This is the dream girl for most teenage males, a gorgeous 'girl next door' who both accepts the hero for who he is and scolds him when he needs it. Give her a cute, rounded face with large eyes and a long ponytail (with the potential to come loose in dramatic scenes!). She should be petite – around six heads tall – with a curvy figure. A short skirt and knee socks will make her look cute and preppy.

PRO TIP!
Hair and eyes

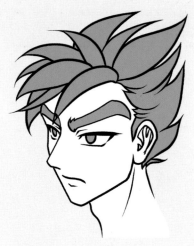

Spiky hair is a true staple of Shounen manga, and every series will have several characters with it in various forms, whether long or short, slicked forward, or swept back. But, these styles are harder to draw than you might think. Make sure each spike's roots come from the centre of the head before bending in any other direction. Connect the spikes to the hairline and sideburns with several short strokes.

Aloof senior

Icy and unattainable, yet aspirational, the senior, or 'Sempai', is a character that the hero looks up to. This character is older, wiser, usually more powerful than the hero, often mentoring him. She is tall and slender, so over seven heads tall. Her eyes are narrower, and rectangular glasses give a cold, analytical look. Her long hair is loose, but perfectly combed, nothing out of place. Concentrate on long, elegant lines throughout – long sleeves, side seams on her trousers, knee boots rather than short shoes.

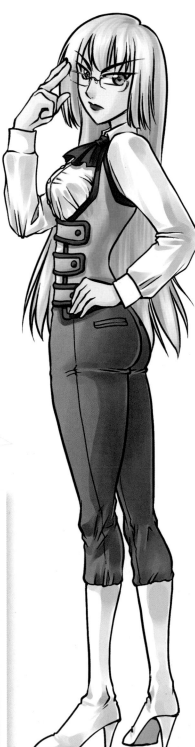

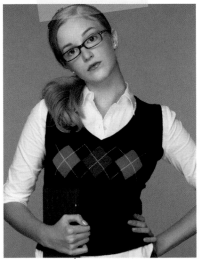

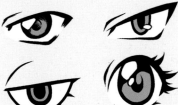

Shounen eyes are stylised and prominent, with strong shapes and clear definition. Here is a variety of shapes to suit different personalities. Triangular eyes show more focus and determination; round eyes appear young and innocent.

DRAW YOURSELF AS A FANTASY HERO

Swords and sorcery are popular themes in action and adventure stories. Fantasy settings really let you play around with special effects. So, let's try drawing a sorceror!

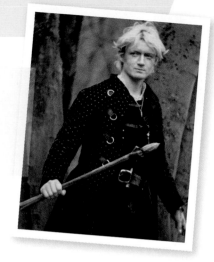

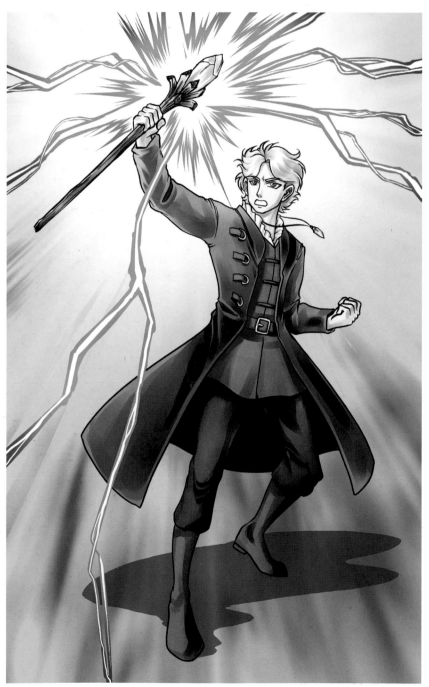

Final image

Photo source

Our photo reference has kindly done some work for us, as he's already dressed in a fantasy costume for a live-action role-play event. Note his blond curls, the cut of his jacket, the different layers he's wearing, and the design of his staff.

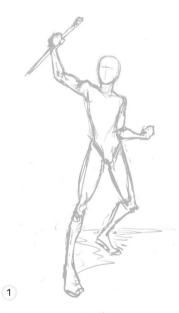

① Draw the basic figure for a dynamic, spell-casting pose (see Pro Tip, opposite). It's important to get this right before adding any clothes on top. (You can trace the figure template on page 45 if you find this too difficult.)

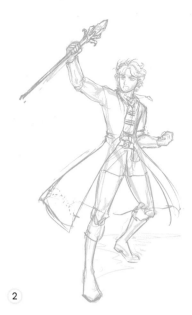

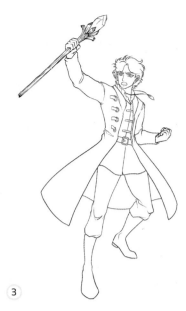

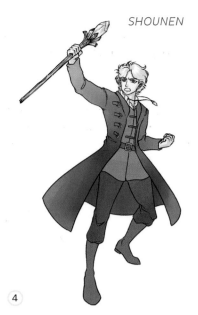

(2)

Add his specific details to your rough pose. You can exaggerate his eye shape by making it sharper, but make sure you get those curly locks flying around! His jacket can billow out for dramatic effect.

(3)

For a more Shounen look, make your inked lines bold and expressive. Put the buckles, belts and straps in, but leave out the studding on the jacket to prevent things from getting too busy. More lines on the wooden section of the staff will add texture.

(4)

There are both light and dark colours in this character's outfit, but you need to ensure high contrast. So, when shading in the light parts, like his skin and hair, focus on the shadows and leave any highlighted areas white. For the dark sections, use a gentle wash or fill in a medium shade.

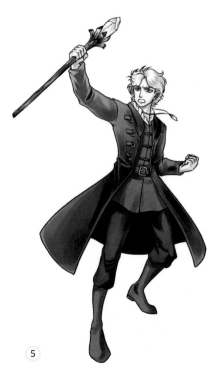

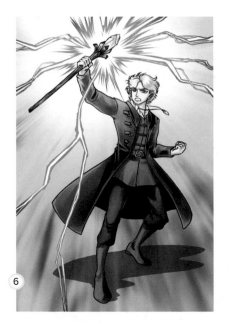

(5)

Sweep rich, dark shadows over the rest of his outfit in bold strokes. Try to imagine light emitting from the crystal in his staff, which will mean positioning shadows away from it. Add saturated accents to the skin and hair sparingly.

(6)

This drawing is all about casting a spell, so create impact with contrast and movement. A spiky halo around the crystal with shards of lightning emanating from it looks powerful. Adding a halo and gradient to the background and a shadow beneath him also reinforces the effect.

PRO TIP!
Picking a pose

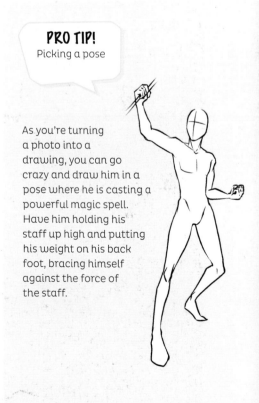

As you're turning a photo into a drawing, you can go crazy and draw him in a pose where he is casting a powerful magic spell. Have him holding his staff up high and putting his weight on his back foot, bracing himself against the force of the staff.

DRAW YOURSELF AS A MECHA PILOT

A popular theme in many Shounen series is mecha: giant, fighting robots! So, why not try drawing yourself as a pilot standing on the shoulder of your robot?

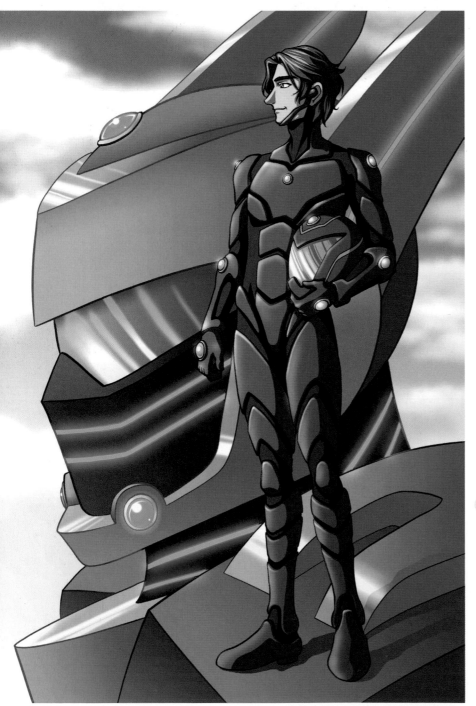

Final image

Photo source
Our real-life protagonist has a square jaw, sharp features, longish hair and a slim build. These are the things that you will have to take note of for this exercise.

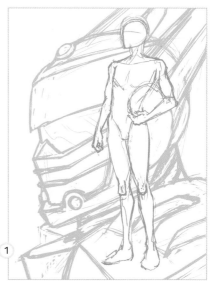

For a classic pose and composition to show off both pilot and robot, sketch the pilot's figure in a confident stance, helmet in hand so that his head is visible. (See the template on page 45.) It's key to get the nude body right, as a mecha pilot often wears a very form-fitting plugsuit. Draw a close-up of the robot's head, and position its shoulder under the pilot's feet.

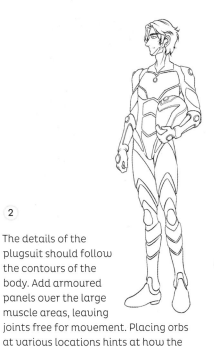

2

The details of the plugsuit should follow the contours of the body. Add armoured panels over the large muscle areas, leaving joints free for movement. Placing orbs at various locations hints at how the suit is powered, or how the pilot controls the robot.

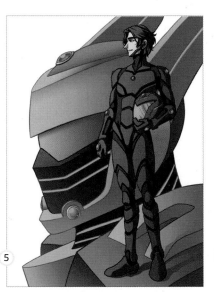

3

The robot's head is similar to a human's. The nose and mouth area is enclosed within heavy 'brows' and a chin guard. Orbs are repeated in the design to link it to the pilot.

PRO TIP!
Highlights

To give the impression of highlights over a very smooth surface, such as metal or glass, use parallel diagonal streaks in bright colours. As the surfaces of the mecha robot are slightly curved, the highlights are also curved to match.

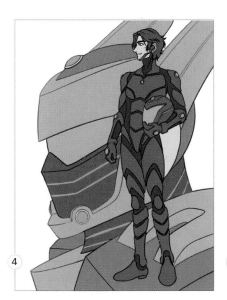

4

Once you have matched the hair, skin and eyes to the photo, go for a dark base on the plugsuit first, then a medium shade for the armoured panels. Stripes and orbs should be brighter, like neons, for a sci-fi feel. The robot has warm colours to match the pilot. Soften the lines of the robot by tinting them to match the fills; this pushes him further into the background, making the pilot stand out more.

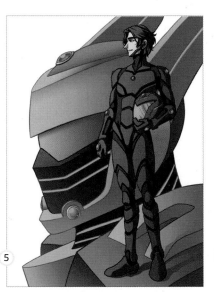

5

The pilot in the foreground has a slight gradient shadow across his whole figure, but is otherwise shaded with very sharp, cel-art shadows. The robot in the background is shaded in gradients throughout to help emphasise its scale, smooth surfaces and curved edges.

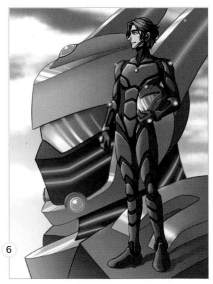

6

Now, add bright highlights across the image in saturated colours to bring it to life: a dot in the eyes and long streaks in the pilot's hair, slashes of light on the reflective surfaces, and a glow on the orbs and neon racing stripes. The background is a brilliant sky with glowing clouds.

DRAW CUSTOM SPORTS EQUIPMENT

Shounen manga frequently features sports, whether it is the driving force behind the main protagonist, or something the characters get involved in during the story. But, the beauty of drawing comics about sports is that you can let your imagination run wild with special powers and effects!

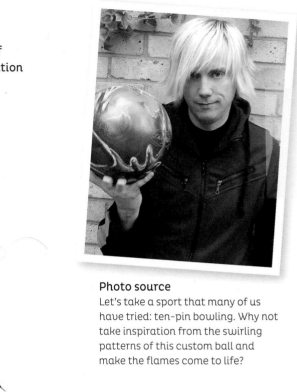

Photo source
Let's take a sport that many of us have tried: ten-pin bowling. Why not take inspiration from the swirling patterns of this custom ball and make the flames come to life?

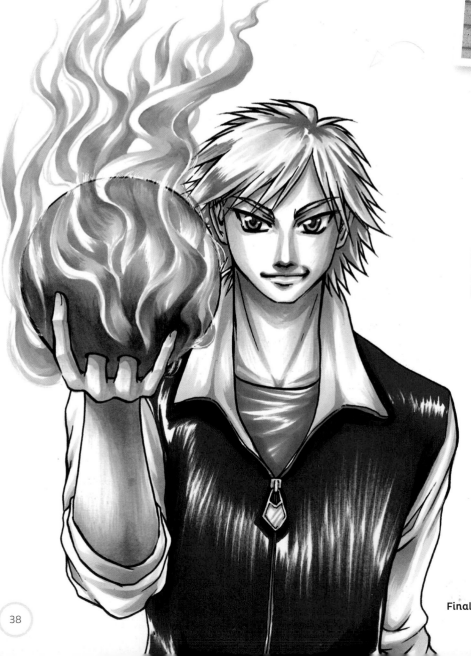

①

Start with a sketch of your protagonist holding the ball up correctly. (See page 45 for a template.) Make sure you position his palm under the ball, and place the correct fingers in the holes.

Final image

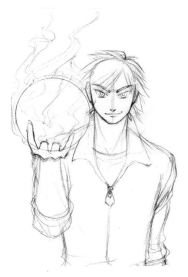

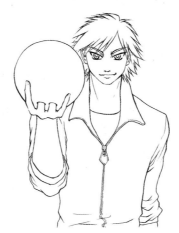

2

Now add some over-the-top Shounen elements! Give your character spiky hair and a cocky expression, then set the ball aflame with psychic powers.

3

Use a pen with a flexible tip so that you can ink the fine details of the face, then press harder for thicker lines around the edges and on any foreground objects. Leave out the outlines of the fire at this stage.

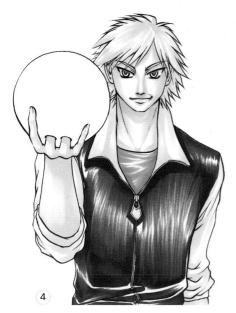

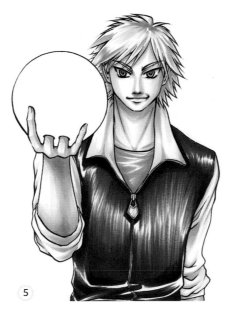

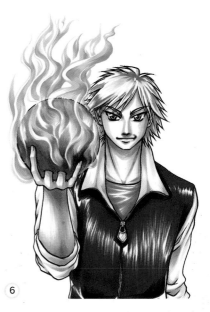

4

Start adding your shading with markers; stick to one colour/shade per section for now. Use the white of the paper to the fullest by concentrating on colouring in only the shadows. The body of the jacket is darker, so colour more of it in, but leave small white slashes as highlights.

5

Add a darker shade to some areas to increase contrast – a light brown to the hair, mid-grey to the whites, and dark grey on top of the reds. Showcase the very darkest shadows and creases, and mark out areas where the light slips into shadow for maximum impact. Finish his eyes in gold to imply super powers!

6

Complete the image by adding white ink to the eyes and over the outlines of the bowling ball to soften the black lines. Then, use a purple marker to shade in the rest of the ball (see below for details on how to add the flames).

PRO TIP!
Supernatural flames

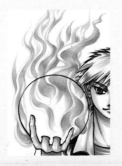

For a supernatural flame effect in subtle shading, don't outline the flames in black ink. Use a marker in a very light shade of green to outline wiggly parallel waves. Then, with a darker blue–green shade, start adding brushstrokes in undulating sections. Finally, blend the darker shades in with the lighter shade.

DRAW YOURSELF AS A SPORTS STAR

Shounen manga is all about personal growth and becoming a hero in your chosen field. Some of the most famous series are about sports, and what better setting is there for displaying rivalry, sportsmanship and striving for excellence?

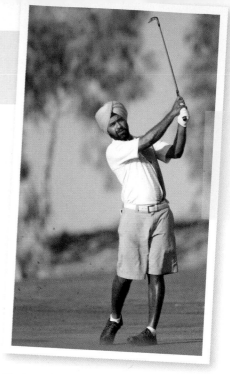

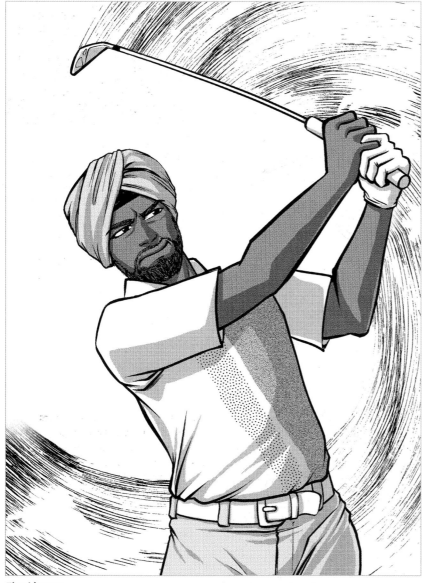

Final image

Photo source
Our subject is a champion golfer. This pose provides a fantastic reference, so study it closely. Take note of his glove and the head of his golf club; remember to bring these things through in the final image.

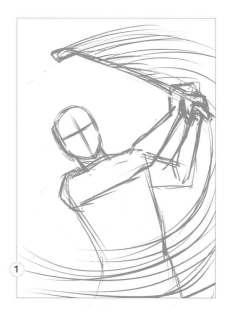

To show off the action of the golf drive but keep the intensity of his stare as the ball flies off, zoom in and frame him with the path of the swing. (A full-figure template is on page 45.)

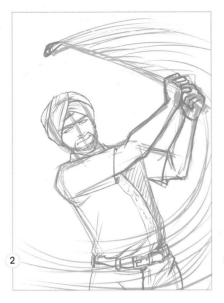

2

When adding details, try to capture the confidence and concentration in the golfer's facial expression. Refer closely to the photograph to get his clothes and accessories correct. Check his hand and finger position, too. See how he's interlocked some of his fingers?

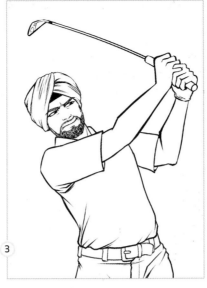

3

Use bold, confident lines and build up the line weights on large shapes and things in the foreground. Fill in his beard with lots of short strokes. Draw in all the folds and creases on his clothes and turban with sharp, tapered lines.

PRO TIP!
Layering

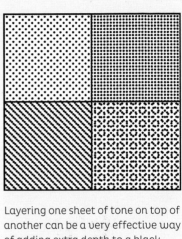

Layering one sheet of tone on top of another can be a very effective way of adding extra depth to a black-and-white screentoned image. But, the way you place it can make a big difference. Here, 10 per cent grey is laid on top of itself again so that it aligns perfectly (top left), perpendicular (top right), diagonally (bottom left), then rotated by 45 degrees (bottom right).

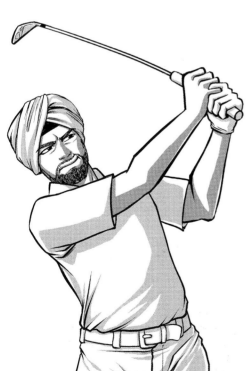

4 If finishing the image in black and white, start by laying down the shadows first, towards the right of his figure. Use a 20 per cent grey tone for most of the image because he is wearing light shades, but switch to a 40 per cent grey for his skin because it is darker.

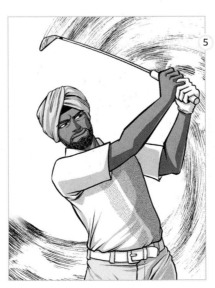

5

To finish the image, add flat layers of tone and patterns for his skin, turban, shorts and polo shirt. A spinning whirlwind-effect tone to match the path of his golf swing provides the perfect background.

DRAW A COMIC STRIP: A NIGHT AT THE MALL

For a real challenge, try to pull together all the elements discussed so far and create your own comic strip using photo references – or just your imagination! Shounen comics will tackle lots of situations that challenge the protagonist and his friends, so the example below was based on a topic that comes up time and again: a game of truth or dare.

① Scripting

Keep your dialogue to a minimum – only use it where necessary. Hint at the circumstances that led to this moment rather than spelling it out too much. Throw in a shock moment at the end, too!

> **SCRIPT**
>
> *It's dark. A young boy is lit only by his torch.*
>
> *DHRUV: We made it.*
>
> *CONNOR: Whoah! It looks really different at night …*
>
> *Camera cuts behind them, showing the interior of a dark, empty shopping mall.*
>
> *CONNOR (nervously): Hey, can we go now? I'm starting to get the creeps.*
>
> *DHRUV: No, I need to bring back proof to win the dare.*
>
> *SECURITY GUARD: HEY! WHAT ARE YOU KIDS DOING HERE?!*

② Storyboard

You must really aim to show, not tell. Shounen comics try to provide more visually by showing the characters in their environment. So, allow for a big panel to show the shopping mall, and make the last panels irregular to match the surprise.

2a: Keep the content in the panels interesting by switching the zoom and camera angles. Start with a close-up, lead the eye into the next panel with a speech bubble that bridges the two, then pull out to a big establishing shot. The camera then tracks the boys as they explore, before quick cuts to show the guard finding them.

③ Drawing and inking

Pencil in the characters, keeping them looking distinct; you want them to be recognisable in the dark. Don't take shortcuts with that background shot. Use a horizon line and two vanishing points along it in order to draw the multiple floors of the atrium. Then, when inking, add thicker weights on outlines and objects in front for a more punchy feel.

3a: Embellish the background with a courtyard garden, and give the boys contrasting clothes and hairstyles.

3b: Outline your panels and speech bubbles, and make any corrections with a white gel pen. Start inking foreground objects first, so that you will know how to fit backgrounds around them.

3c: Resize to final print dimensions, and remove the coloured pencil lines. Add your lettering, and correct the bubbles if needed. Then, threshold the art so that it's crisp, pure black and white, and fill in any blacks.

④ Shading with screentone

Shounen characters tend to be shaded realistically, so aim for high dot densities, and put in lots of shadows on the characters where you can. Layer your tones, too, for increased contrast.

4a: There is a lot of dramatic lighting in this scene. It is lit only by torchlight, so there is plenty of uplighting and backlighting. Always consider where your characters are being lit from. Lay down the shadows before adding flats on top, so that it's easier to align tones afterwards.

PRO TIP!
Tones and patterns

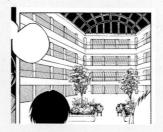

When adding tones and patterns over your inks, whether working digitally or traditionally, start with more than you need, then cut away the extra. Here, the lines for the shop shutters are added as screentone.

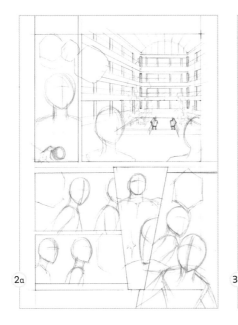

2a

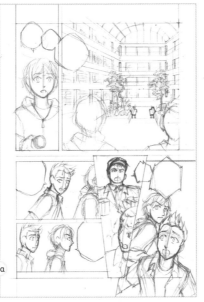

3a

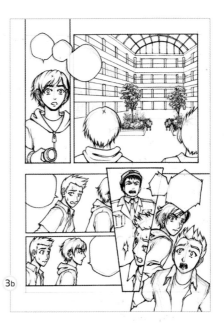

3b

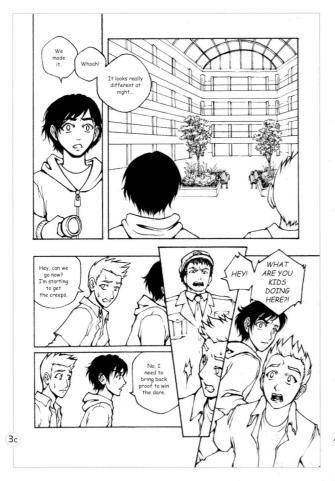

3c

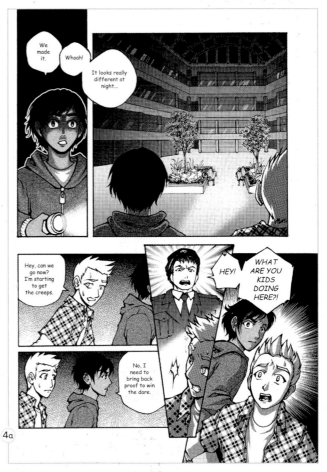

4a

SHOUNEN FIGURE TEMPLATES

It takes lots of practice to get proportions right, but you need to sketch an accurate figure before adding the details of the face, hair and clothing. So to give you a head start, here are all the figure templates for this chapter. Try copying these to help you on your way!

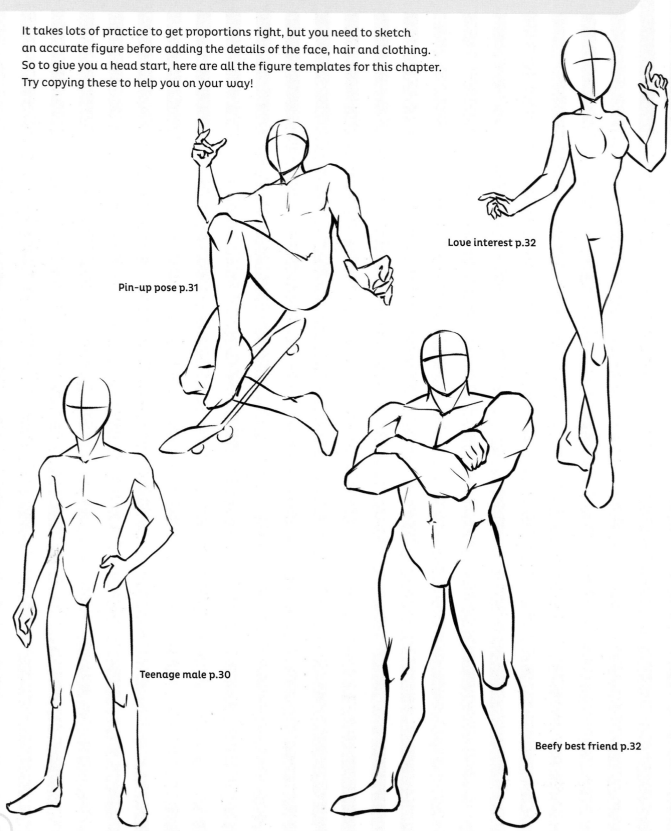

Pin-up pose p.31

Love interest p.32

Teenage male p.30

Beefy best friend p.32

Aloof senior p.33

Mecha pilot p.36

Fantasy hero p.34

Sports star p.40

Sports equipment p.38

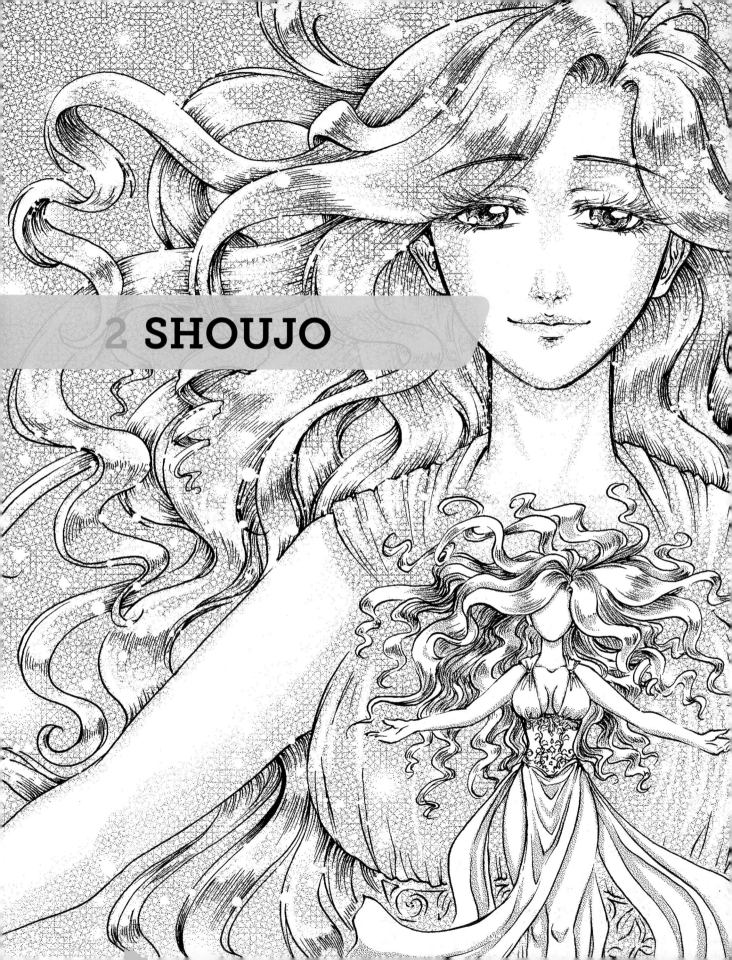

2 SHOUJO

少女漫画

Shoujo manga is marketed to a young female audience aged from 10 to 18. After Shounen manga, this is the second most popular category of Japanese comics, with many being turned into full-length anime series and films, as well as merchandise and toys.

SHOUJO OVERVIEW

As with Shounen manga, Shoujo embraces a large variety of settings and themes. Historical periods, modern-day schools and far-flung fantasy are all fair game. It's quite popular to mix settings, too – there are lots of series that take a lead character from a real-life setting and throw them into another world! Again, there are plenty of positive messages throughout: gaining self-confidence, learning to trust others and, more often than not, finding love along the way.

The focus of Shoujo manga, however, is almost the complete opposite of Shounen. Rather than all things physical, Shoujo is strongly geared towards the emotional – the inner life of a character. What is she thinking about? How does she feel about that other character? Does she know what they think of her? Or maybe she's more concerned about how other people treat her best friend. If thrown into an awkward situation, how does she interact with others to resolve it?

If there is one word to describe Shoujo characters it's 'pretty'! Everyone is depicted with fine, delicate lines and subtle shading – think pastels rather than bright, primary colours. It is also quite minimal; lines are only drawn where necessary. Eyes are large, with sweeping lashes and lots of shiny highlights, whereas other facial features are small and cute, or refined and elegant. Young female characters have rounded faces, while older males are dashingly angular. Hair is thick and lustrous, sometimes with atmospheric, wispy strands. Characters also have hardly any muscle tone; they are either soft and rounded, or thin and bony.

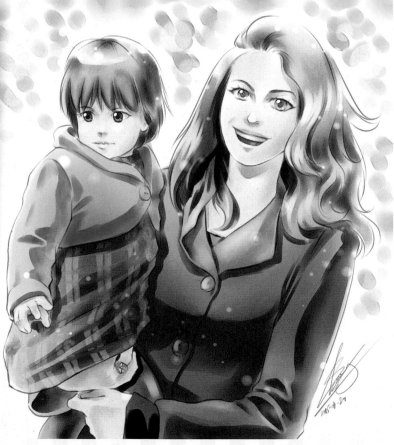

ABOVE AND RIGHT: *Although more realistic than most, this drawing falls firmly into the Shoujo category because of its thin lines, many gaps, the sense of lightness from the soft, impressionistic colouring, and areas of white canvas.*

To meet the demands of creating pretty characters and emphasising their emotions, Shoujo manga is storyboarded in a sparser, more open way than Shounen. There are fewer panels and many more close-ups to show every nuance of expression, from the angle of an eyebrow to someone biting their lip. There is also a lot more abstraction from reality with the use of backgrounds that reinforce atmosphere rather than physical surroundings (perhaps pretty bubbles to indicate that something nice is happening), or visual metaphors (like having a character floating in darkness to indicate loneliness).

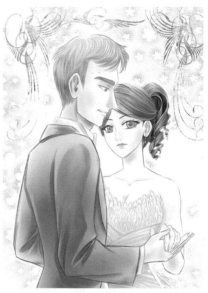

ABOVE: *This bride and groom were drawn digitally in a classic Shoujo style. The line work is very thin, clean and minimal, softened even further with the addition of colour – very soft, subtle pastel shades, appearing only in shadowed areas rather than in flat fills.*

LEFT: *Even when coloured in an anime cel-art finish, the Shoujo style of this is very clear from the way the character has been drawn and shaded: thin, delicate line art, pale fills with saturated shadows, lots of detail in the hair, and sharply elegant facial features.*

DRAWING SHOUJO-STYLE CHARACTERS

Shoujo features delicate line work and soft shading. Females are depicted with cute faces and large, sparkly eyes with fluttery eyelashes. Males are tall and sharp-featured, with an androgynous, elegant beauty. Bodies tend to be slim and simplified; bones are defined but muscles are not. Here are some of the key characters found in Shoujo series. (Templates for them are provided on pages 62–63.)

Main protagonist

A young girl between 10 and 16 years of age is the usual protagonist of Shoujo stories. She is generally quite normal, maybe with a gift, such as being a good singer or athlete. Maybe she is chosen by a magical being to help fight crime! As with Shounen comics, readers follow her journey as she develops confidence in herself and others.

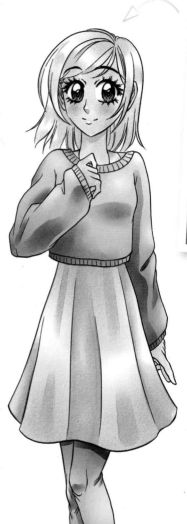

Clothing
Dress her in clothes that are modest and cute, like pleated skirts and baggy jumpers.

Body type
The heroine is usually of average or petite stature, about six heads in height. She tends not to be curvaceous. Shoujo style has very little muscle definition, but you can show bones at the wrists, knuckles and collarbone if you want to add more detail.

Drawing notes
Use thin, delicate lines when inking. There shouldn't be too much variation in line width – leave gaps in your lines if you want to hint at swells and curves, and don't use more lines than necessary. Shading is subtle and soft. Watercolours are ideal for this style, with lots of washes, fades, blends, soft and less-defined highlights, and shadows.

The face
Our heroine is mild-mannered, so her eyes are large, with a gentle, sloping curve, giving her a kind look. Her hair is understated, in a shoulder-length, layered cut that can be worn in a variety of styles throughout the story. She has a cute blush to her cheeks.

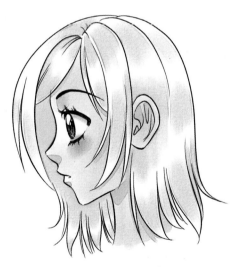

The profile
To make her look cute and delicate, use curved lines and keep her nose small, high and snubby. Don't let the lower half of her face stick out too much.

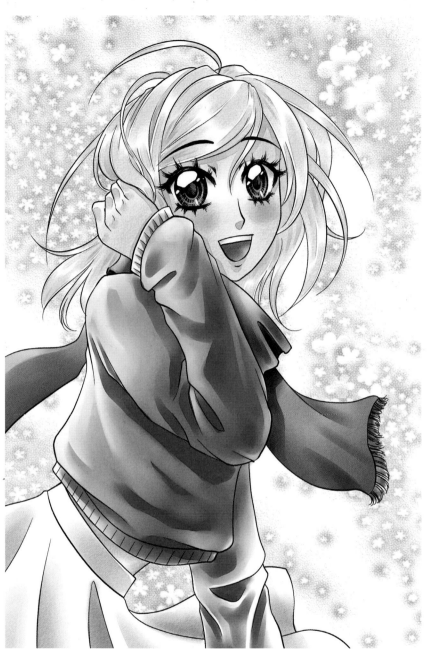

Pin-up pose
Shoujo manga focuses very strongly on emotions and showing off how pretty the characters are, so the best pin-up shots are medium close-ups. A charming pose, like her holding her hair back from her face as the breeze blows flower blossoms behind her, and ruffles her hair, scarf and skirt, is perfect! Focus, too, on capturing the movement around her.

Supporting characters

Shoujo manga is all about relationships and the way characters interact – the looks they give, the way they touch, what they say and how often, and what they choose not to say. The supporting characters may not be as physically different and dynamic as Shounen, but the roles they play can be far more crucial and entangled with the heroine.

Bad boy

The other love interest is the complete opposite – wild, reckless and spontaneous! He goes to a different school, gets into fights and plays truant just so he can make eyes at our heroine, whom he likes because she sees the best in him. Design his look to match his attitude – think rock star with long bleached hair, sunglasses, red jeans, sheepskin jacket and boots. He should have angular eyes, quirky eyebrows and a crooked smile.

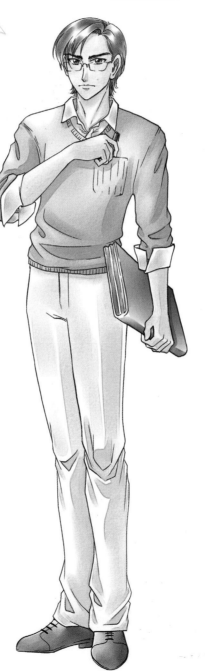

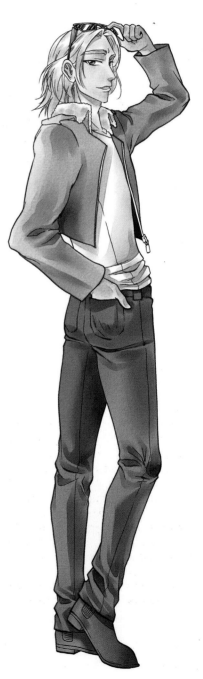

Sensible student

The first of the love interests, he is studious, serious and responsible. Older than our protagonist by a few years, he can't help wanting to protect her from harm. This is also his flaw; he comes across as controlling in his quest to seek what is best for her. He is conventionally attractive, but give him a look that reinforces his personality: glasses, large eyes with angled eyebrows, a medium/short haircut. His clothes should be responsible and stylish – shirt, jumper, chinos, brogues.

Shoujo manga panels have all sorts of interesting things in the background, usually to reinforce the key emotion in the scene. Flowers are a common motif, surrounding a character who is either beautiful or kind. Dots, bubbles and sparkles are also popular – they give a sense of wonder, renewal or acceptance.

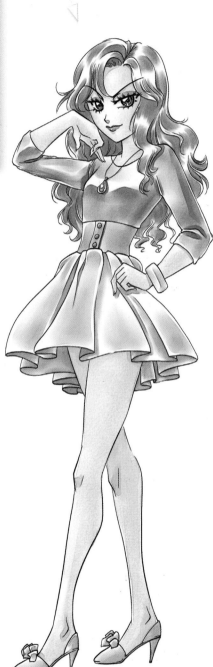

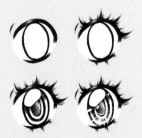

Shoujo eyes are famously large, round and sparkly. There are many ways to draw them, but the general theory is the same. Start with a large, rounded frame, then thicken the lash lines with lots of little lines rather than one thick stroke. Add fluttery eyelashes flicking out at different angles. Next, mark out a large highlight in the eye before shading in the pupil and iris. Concentric circles work well, along with cross-hatching. Finish by adding more highlights on top – dots around the main one and then lines along the bottom.

Ruthless rival

The rival is a beautiful part-time model, with perfect hair and make-up. She has boys wrapped around her little finger, and girls are desperate to be her friend. But, she is jealous of the attention the heroine gets from the two love interests, so she schemes to get her into trouble. Although her body type isn't so different from the heroine, the way she stands and holds herself should be confident – almost aggressive. Her angled eyes should have heavier lids and her thin eyebrows should have a cruel slant.

DRAW YOURSELF AS A HARAJUKU GIRL

Mention teenage Japanese street fashion and, chances are, everyone will talk about the famous area of Tokyo where young people wear their most outrageous outfits. Harajuku girls are well-known followers of the latest trends and innovations, and they aren't afraid to show it!

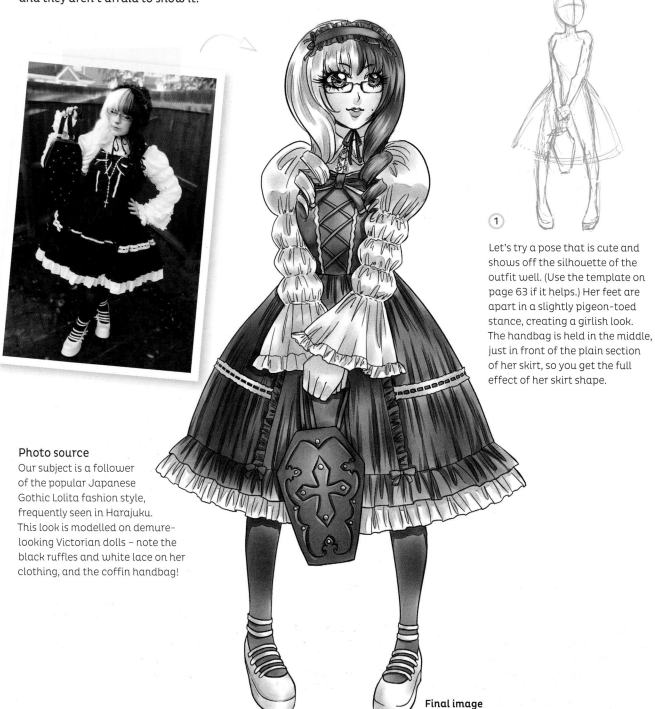

Photo source
Our subject is a follower of the popular Japanese Gothic Lolita fashion style, frequently seen in Harajuku. This look is modelled on demure-looking Victorian dolls – note the black ruffles and white lace on her clothing, and the coffin handbag!

Final image

1

Let's try a pose that is cute and shows off the silhouette of the outfit well. (Use the template on page 63 if it helps.) Her feet are apart in a slightly pigeon-toed stance, creating a girlish look. The handbag is held in the middle, just in front of the plain section of her skirt, so you get the full effect of her skirt shape.

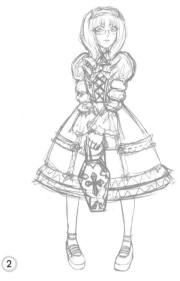

2

This style of dress has a very distinct shape and volume. Shape the puffy sleeves around her arms correctly, and position the lace and ruffle detailing in a gentle curve around her skirt. Don't forget the lace-up ribbons in her bodice, and count the straps on her shoes.

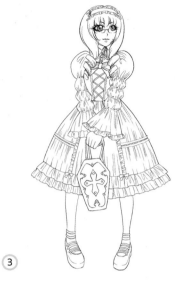

3

Use fairly thin lines to ink her, particularly when you start adding the creases in the fabric and extra strands in her hair. This will take a while, but be patient – the final effect will be impressive!

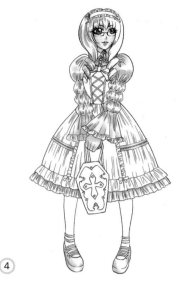

4

Whether painting traditionally or digitally, try to use the white of the canvas where possible. Start with the light-coloured areas like the skin and eyes, and the whites, such as the blouse, shoes and the hair on her left side. Concentrate on the shaded sections and blend them out until transparent for highlights. Then, add darker, sharper shadows as needed.

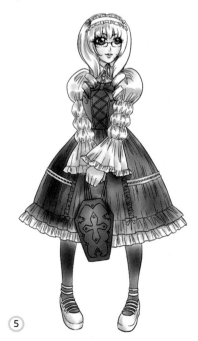

5

As there is lots of black in this outfit, start with a general wash over the remainder of the image and blend in some water/transparency in the centre of better-lit areas like the middle of her handbag, and the right of the image.

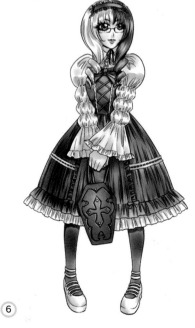

6

Once you have laid down the dark wash, add sharp, more opaque slashes of black and dark grey into the shadowed areas, concentrating on the creases, shadows cast by her arms, and streaks in her hair.

PRO TIP!
Drawing curls

Lolita fashionistas often sport beautiful spiral curls. They are not as difficult to draw as you think. Start with some parallel skewed rectangles that get smaller. Then connect them in the other direction. For the final look add some texture and shading with your line art.

DRAW YOURSELF IN A JAPANESE SCHOOL UNIFORM

A great majority of Shoujo manga involves high-school romances. So, what better way to tap into Shoujo sensibilities than to try drawing yourself in an iconic Japanese school uniform?

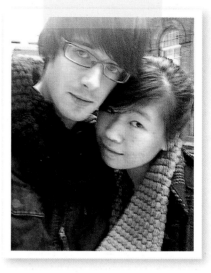

Photo source
A selfie of a cute couple makes a great starting point here! Take note of their hairstyles, his glasses and their hair and eye colour, and be sure to add all of this in later.

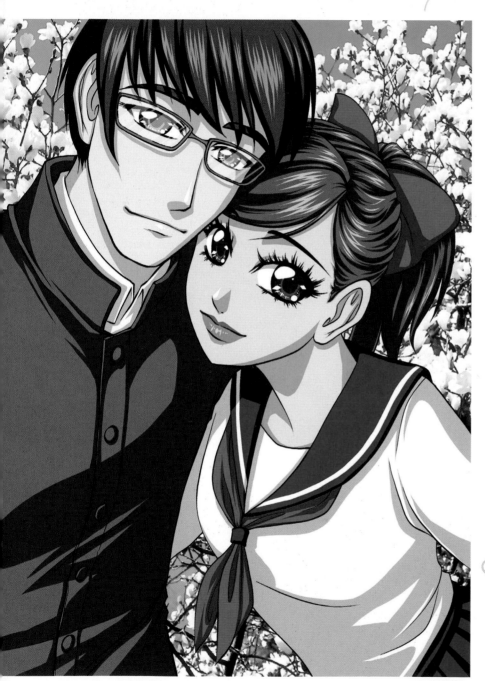

Final image

1

The pose is already perfect for a romantic mid-shot zoom, so let's use it. (A full-figure version is on page 63.) Sketch the figures close to each other, getting their relative heights right and tucking the girl under the boy's arm.

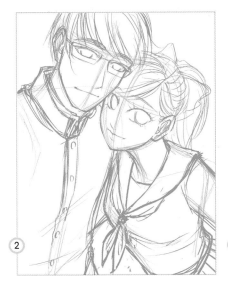

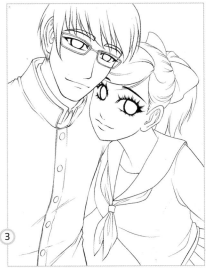

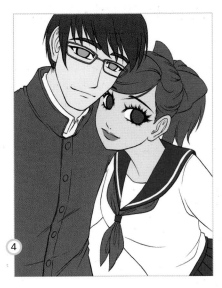

Make the hairstyles and face shapes as accurate as possible, then add embellishments where needed, such as a bow in her hair. There are many styles of school uniforms in Japan, but the classic ones are based on the military or the navy. Here, we have a black jacket with a standing collar over a white shirt for him, and a sailor collar and pleated skirt for her.

Use thin, delicate lines to ink throughout. Concentrate on making the hair look as silky as possible, with lots of individual strand details. Work on drawing tapered ends for the sweeping eyelashes.

Digital cel-art shading always starts with a layer of flat colours in the base shade – the main colours for each surface – before any lighting effects are added. Shoujo palettes are quite light and desaturated, so don't make the colours too strong.

PRO TIP!
Drawing glasses

Always start with a guideline across the bridge of the nose to make sure your glasses aren't crooked – unless it's intentional! Then, use another line for the bottom of the frames – more, if required – so it becomes much easier to fill in all the details and keep everything aligned correctly.

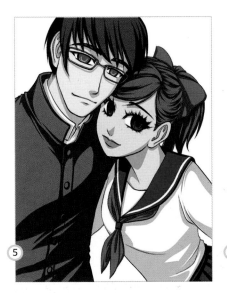

The key to achieving a Shoujo feel to cel-art images is to make the shadows reflect the sense of delicacy in the line art. This means punctuating main shadow areas with lots of smaller, sharp details like creases or strands of hair.

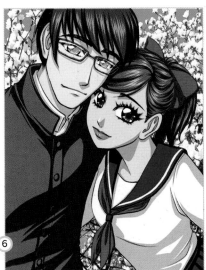

Add fine highlights to hair, circular and diamond-shaped white highlights to eyes, semi-opaque white streaks across his glasses, and a suitable background for young love – magnolia blossoms! (Try keeping a collection of your own photos to use as backgrounds.)

DRAW YOURSELF ON A DATE

Being able to draw a stylish couple out on a date is absolutely essential if you want to try creating Shoujo manga. Make an effort to make them as beautiful and sparkly as possible. (Note, too, how the woman's eye sits over the top of her hair. This is a common Shoujo look.)

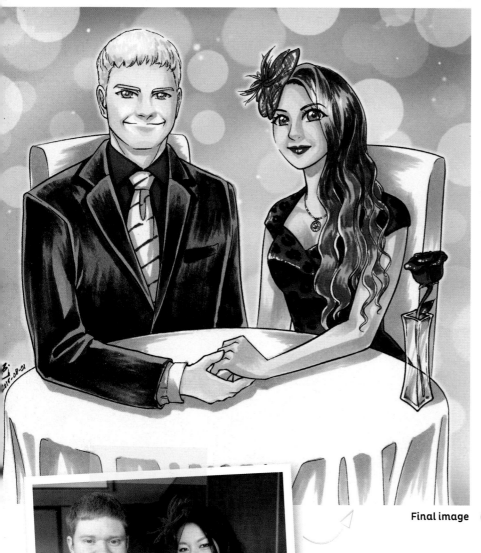

Final image

1

Have your couple settle down for a romantic dinner. Block out their overall silhouettes, holding hands. Sketch the shape of the table and chairs. (You can see their full figures on page 63.)

2

Photo source
Our happy couple has made this exercise a joy – they are so well coordinated! Note the use of red and black throughout, the cut of the dress and her colourful hair.

Now, spend time drawing the details of their features and the key design elements of their clothes. He has very short hair, so get his hairline right. Her hair is swept sideways, and her dress has a crossover front with cap sleeves.

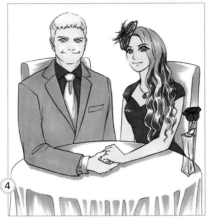

For the Shoujo look, keep your lines delicate, simple and clean. Gaps add to the light feel. Use lots of eyelashes for the woman, and wispy parallel lines for her wavy hair.

Start colouring in with lighter shades first. For dark areas like the suit, dress and the woman's richer skin colour, flat fill. For lighter areas, try to leave any highlighted areas white. For the white tablecloth, only colour in the shadows, and leave everything else white.

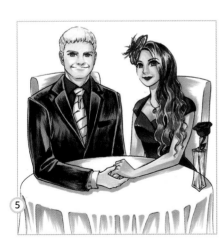

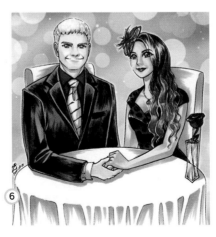

Now, add in another layer of darker colours for shadows all over the image. Switch back to using the lighter shades and paint over while the edges are wet whenever you want to blend the shadows out more smoothly.

Finish the image by adding a few highlights in white ink on top, then create a soft, bubbly background so that the whole scene feels sparkly and magical!

DRAW A COMIC STRIP: SLEEPOVER

Shoujo comics feature girls having fun with their friends and confiding in them. So, a sleepover, where giggles and secrets start spilling, is perfect. If your skills are up to it, let this comic inspire you to produce one based on your own friends!

1 Scripting

Teenage girls often worry about how they are seen by others. But, with their friends behind closed doors they can let loose and be more playful. Of course, that doesn't stop some of them from voicing their insecurities.

SCRIPT

Feathers fly around in disarray.
VALERIE: Kyaaa!
JENNY: Haha, got you!
Camera pans out to show the two girls engaged in a pillow fight in a bedroom. Cut to a mid-shot of Marian with a stern face, arms folded.
MARIAN: Seriously, you guys, we aren't ten years old, we should – OOF!
Close-up shot: She is cut off by a pillow thrown in her face. Marian picks up the pillow and chases Jenny with it.
MARIAN: REVENGE WILL BE MINE!

2 Storyboard

Shoujo manga focuses on character interaction. Imagine fading into a pillow fight scene. Start with an abstract shot of feathers floating, which pans back to show their origin: the pillow fight. Finish in a light-hearted manner that pulls the serious girl into the fun.

2a: Two key moments in this scene need to be highlighted – the pan back to the pillow fight reveal and the shot of Marian talking because she says a lot, so the shot lingers on her for longer. Make these panels larger than the others.

3 Drawing and inking

Next, pencil in the different body shapes, hairstyles and clothing. When inking, use only one or two pens so that the lines are fairly thin and consistent throughout, and keep your lines neat and minimal. When you scan and clean your artwork, add lettering so you can fix speech bubbles before shading.

3a: Although detailed backgrounds aren't hugely important in Shoujo manga, draw enough of the bedroom to set the scene.

3b: Start with the panel borders and speech bubbles. Then, use a smaller pen nib for the faces before switching back to a larger pen for everything else.

3c: Now, resize to final print dimensions and remove the coloured pencil lines; threshold the art so it's crisp, pure black and white. Keep black fills to a minimum.

4 Shading with screentone

Shoujo manga is known for its use of cute patterns, so use larger dots in lower densities. Layering pretty shapes and flowers on top of everything works well, too.

4a: All the coloured areas (such as clothes, brown hair, wooden furniture) are flattened with tones. Then, cute and pretty effects are added on top or in the backgrounds.

PRO TIP!
'X' marks the spot

Most manga artists use crosses to draw their attention to something in the inks, whether it is to correct a mistake once scanned, or to fill in an area in black later (either with a brush or digitally).

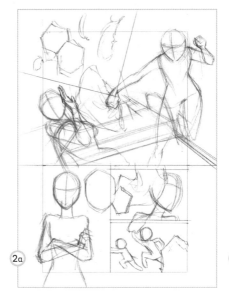

2a

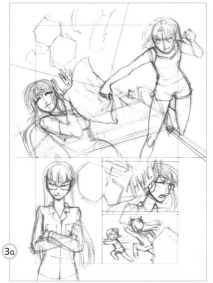

3a

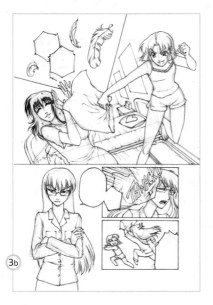

3b

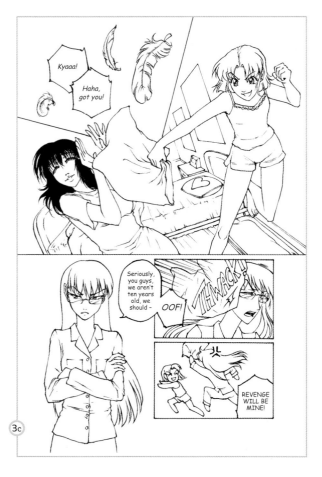

3c

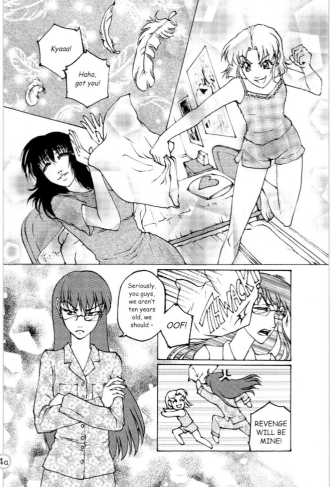

4a

SHOUJO FIGURE TEMPLATES

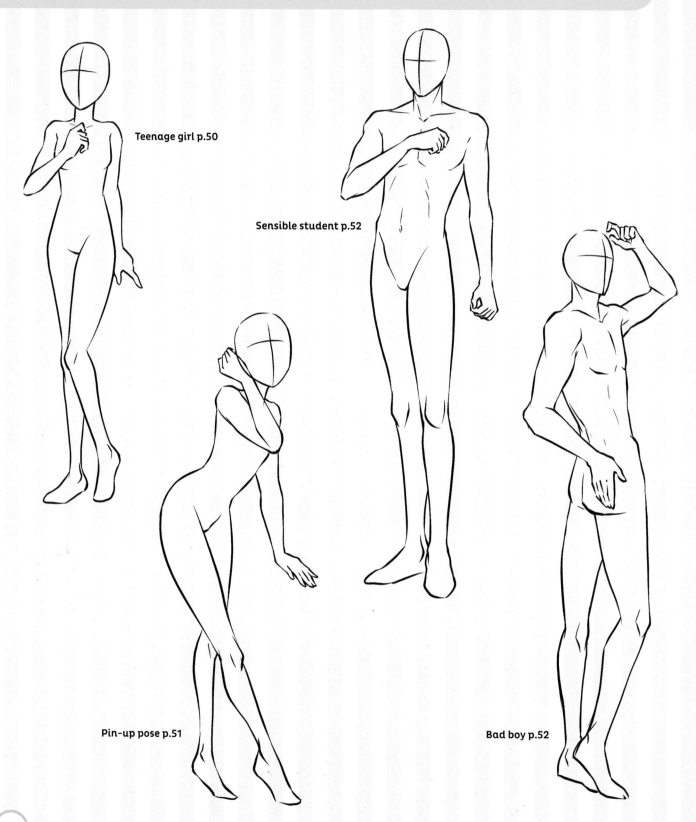

Teenage girl p.50

Sensible student p.52

Pin-up pose p.51

Bad boy p.52

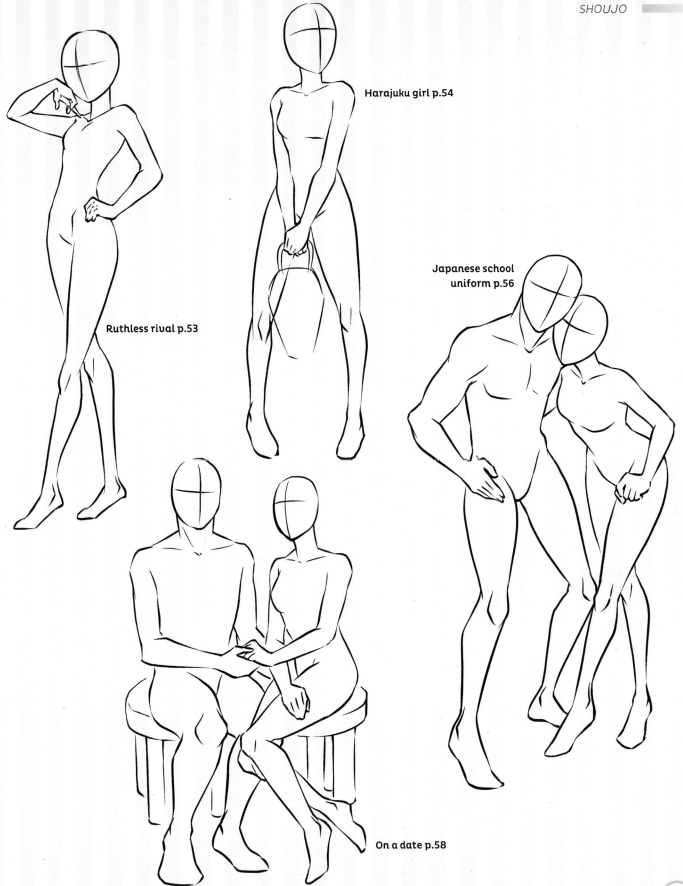

Harajuku girl p.54

Ruthless rival p.53

Japanese school uniform p.56

On a date p.58

3 SEINEN

青年漫画

Seinen manga is marketed to a male audience aged 18 to 30. Seinen features many of the same basic themes and sub-genres as Shounen, but they are often more psychological, satirical, violent and sexual in nature since they are intended for a more mature audience.

SEINEN OVERVIEW

Seinen manga focuses more on plot and slightly less on action. Characters and their interactions are more sophisticated. Overall, Seinen tends to be more strongly rooted in reality, with many incidental details added to heighten the sense of realism – even fantasy elements are subject to a strong 'realistic' logic. Whereas Shoujo will feature idealised love stories, Seinen will include more greys and uncertainties, dealing with the practical give-and-take realities of a relationship, including the physical side.

These are generalisations, however, and even if a series has none of these characteristics, it can still be classified as Seinen if it is intended for that target audience. As a result, the appearance of Seinen manga is widely varied, including hyper-realistic, loose sketches and crude simplicity. What is common throughout, though, is that the drawings are not conventionally slick, beautiful or typical of what we expect popular manga to look like!

Seinen manga is often far removed from the typical character designs you would expect to see in popular Shounen and Shoujo series, as it's much more realistic. It may feature older characters or more believable facial characteristics, such as smaller eyes and wrinkles. Any technical details are also usually very well researched and accurately depicted.

LEFT: *Fantasy heroes are drawn with lots of detail and shading, usually using pen and ink hatching. This image is mostly monochrome, with flashes of red blood and glowing yellow eyes to add impact. The contour hatching gives it a sketchy feel.*

ABOVE: *Seinen art, particularly regarding male characters, is often the most realistic of the manga styles, with smaller eye sizes and facial lines. Inking techniques with strong blacks can be similar to Western superhero comics.*

ABOVE: *These faces are similar to those found in Shoujo, but the characters are designed to appeal to men – the realistically depicted technical outfits, the backdrop of fighter planes and, of course, the beautiful woman! Both male characters are clearly aspirational types.*

RIGHT: *Contemporary Seinen storylines are often complicated, dealing with characters being manipulated psychologically. Here, someone is being told something they don't want to hear, and it's sending them into a panic. The realistic character designs and thin, sketchy lines put this firmly in the Seinen category.*

DRAWING SEINEN-STYLE CHARACTERS

Seinen artwork uses a wide array of inking techniques, colours and proportions, and mature tastes are more accepting of alternative, unsettling styles. But the look that really comes into its own is that of greater realism and detail. (See pages 82–83 for templates.)

Male protagonist

As storylines are more adult in nature, the main characters also tend to be older – usually somewhere between 18 and 30 years old. Physiques are realistic and not idealised, unless the character is playing a physical role. Facial features are depicted with fine, detailed lines – small eyes, big noses, wrinkles, nostrils and all.

Drawing notes

Ink with fine, straight lines and sharp angles. You can be messy and gritty or clean and sharp, but whatever you choose, stick to it! Use hatching in some areas to increase depth. Many Seinen coloured pieces have muted flats with soft or airbrushed shadows and highlights.

Clothing

Seinen series are grounded in reality to allow for realistic, complex storylines, so clothing needs to reflect this. Study how garments drape and fall. Note, for example, collar designs, points of tension where the body bends, and the crisp fold down the front of trousers.

Body type

This character is fairly normal; he is on the slim side and doesn't go to the gym often. So, no barrel chest or big muscles, and his bones show in some places. He should be slightly above average height, so make him about eight heads tall.

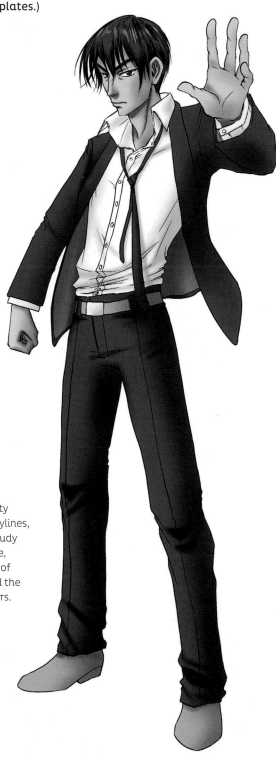

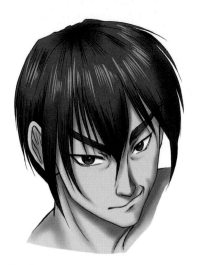

The face

Seinen heroes often have many personality flaws, so include some imperfections and age. This character's lopsided smile and the small lines under his angled eyes imply a belligerent, cruel side.

Female protagonist

Female characters are almost always physically attractive, often wearing clothes that show off the body, or allude to common fantasies (schoolgirl, nurse, secretary, and so on). Whether she is embarrassed about it, or embraces it, is up to you! The open posture and outfit of the woman here show that she isn't shy about her body. Softly shade her curves to maximum effect; imply her contours beneath the fabric as well. Highlights are particularly sensuous on darker skin.

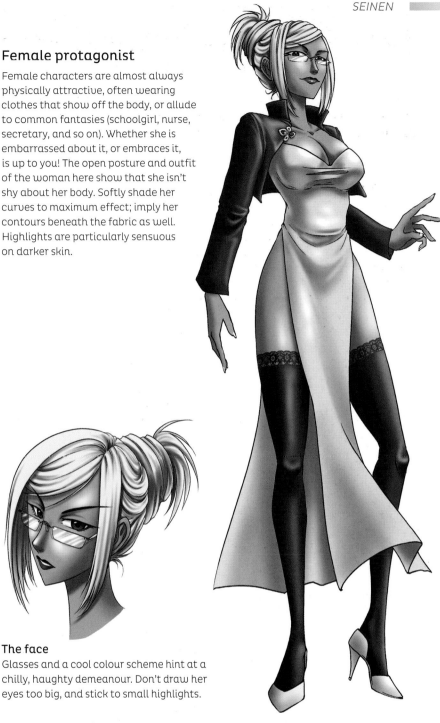

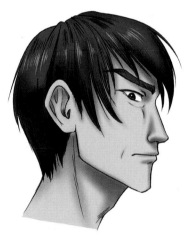

The profile

This is quite rugged. His eyes and irises are small, and the lines around his eyes and mouth are visible.

The face

Glasses and a cool colour scheme hint at a chilly, haughty demeanour. Don't draw her eyes too big, and stick to small highlights.

PRO TIP!
Get your angles right

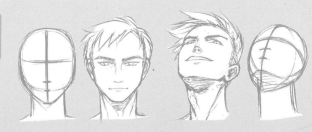

Seinen manga often uses extreme angles to add dynamism and atmosphere. It's important to get them right! Build up your faces from basic guidelines, and position the features correctly. Use a cross hair at the bridge of the nose on top of an egg shape to help you position the eyes, nose, mouth and ears consistently across different angles.

DRAW YOURSELF AS A SAMURAI

As Seinen manga is aimed at an older market, it often deals with a lot of historical settings, showing the struggles and political machinations behind key moments in time. Period drama (Jidaigeki) is a popular theme, and the iconic hero of these series is the samurai.

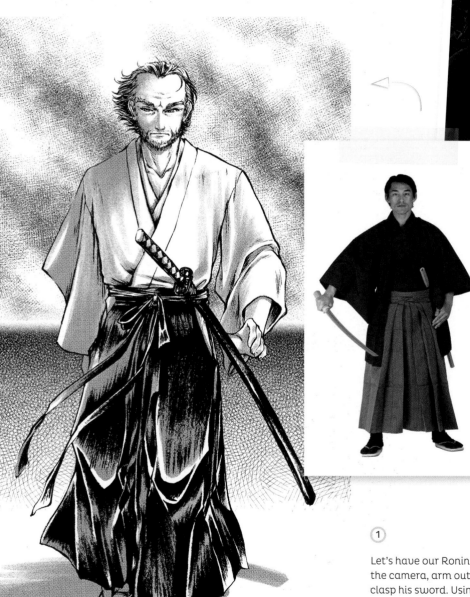

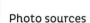

Photo sources
Our photo subject has the perfect look for one of the most popular Seinen hero/antiheros: a grizzled, wandering samurai (or 'Ronin') – a warrior with no master!
We also have a photo reference for a typical samurai outfit.

①

Let's have our Ronin walk slowly towards the camera, arm outstretched, ready to clasp his sword. Using a coloured pencil, build up his body to give him weight and presence. Mark out where his sword would be so that his hand is positioned correctly. (The template is on page 83 if you need it.)

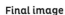

Final image

② Start adding the details of his face and hair. Concentrate on his eye shape, hairline, sideburns and the beard along his jaw. For clothes, he is wearing large, pleated pants, called 'hakama', over the top of a loose, short kimono. He should also wear a 'hadagi' (kimono undershirt), so account for two layers up top.

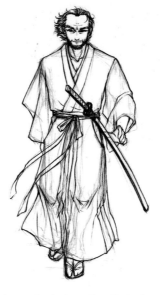

③ It looks particularly authentic to draw Seinen Jidaigeki images with a brush, for texture and expressive lines. If you are working with traditional brush and paper, use only the tip of the brush for the fine features of the face and hair, and for any thin lines elsewhere.

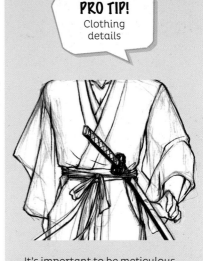

PRO TIP!
Clothing details

It's important to be meticulous when drawing the costume. For example, the sword is tucked into the part of the belt that ties at the front. Also, note which way the kimono folds – left over right, from his point of view. The other way around is reserved for dressing the dead!

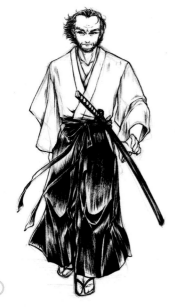

④ Coloured pencil lines make it easy to remove the rough sketch once the image is scanned – simply adjust the levels or colour channels digitally until they disappear and only the black inks remain.

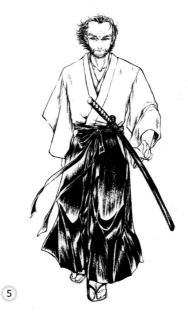

⑤ Using your brush, add in the black shadows on the image. Focus on the black lacquered sheath of the sword, and the criss-crossed wrapping on its handle. Then, paint in sections on the hakama pants, trying to leave creases white to emphasise folds and pleats.

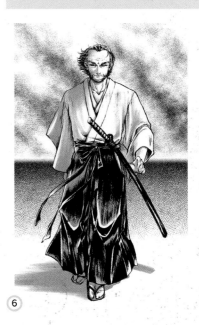

⑥ Adding some screentone as a final touch will give the image some gravitas. Use a fairly dark, close tone like a 30 per cent grey at 60LPI over him, and etch away a mix of sharp and soft highlights. Finally, in the background, some cross-hatched tones will create an ominous, 'scorched earth' backdrop.

DRAW YOURSELF WITH SUPERNATURAL POWERS

Horror, urban myths and contemporary settings with a supernatural twist are common themes in Seinen manga. With this in mind, why not draw yourself as someone with super powers? You could be telekinetic or have the power to manipulate elemental energy!

Photo source
Our subject has a great side profile and a striking hairstyle with bleached spiky ends. Let's show this off properly!

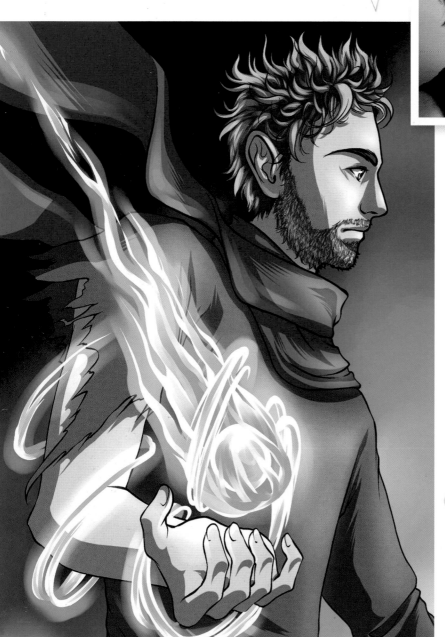

Final image

A mid-shot pose will showcase his face and hair nicely. Using a slightly lower camera angle means we can get a good look at whatever he's going to conjure up in his right hand. (Of course, you can also experiment with the full-figure template on page 83.)

PRO TIP!
Layer settings

It's always worth experimenting with Layer Settings to see the effects you can create when you layer a bright colour over a dark background. The blue glow around the ball looks dull if left as it is, but if you set the Layer to Luminosity or Colour Dodge, it becomes much brighter and more saturated.

2

Add in the details, matching profile and features as closely to the photo as you can. Seinen style can be very realistic. A scarf has been added, which flows behind him dramatically, and his right sleeve is torn as a burst of psychic energy manifests in his palm.

3

Use a smaller brush size for inking the features, then increase it for the rest of the picture, keeping the outline around the whole figure consistent. Make sure, too, that the ends of your lines are sharp and tapered.

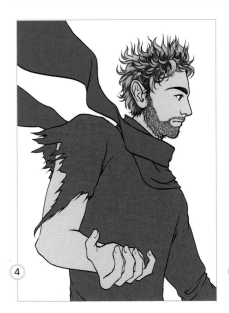

4

Fill in the base flat colours for the image, then paint in the greenish blond tips of his hair and facial hair carefully. Try to keep the strokes clean and crisp – you don't want any muddiness at this stage.

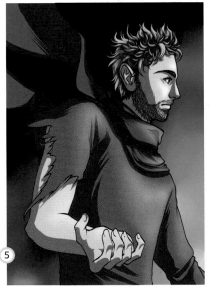

5

Add a dark, foreboding background with eerie neon lighting in smoke. As the colours are quite cool, go for a grey–blue shadow towards the left of the figure in sharp strokes, and a green-yellow, soft highlight, airbrushed towards the right.

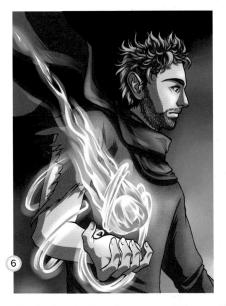

6

The final touch is to draw in a swirling, fiery ball of blue energy. Start with flame-like white strokes on a separate layer on top of everything, leading into the ball. Then add soft streaks of bright blue to give it shape and depth. Finish with swirls around his arm that lead into the psychic fireball.

DRAW A SEXY CRUSH

Any manga aimed at teenage boys and men would be incomplete without a sexy femme fatale – a glamorous and sophisticated woman who mysteriously comes and goes, leaving a trail of broken hearts!

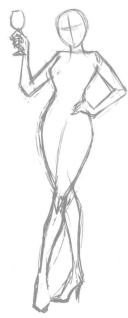

Photo source
Our inspiration is this stunning woman in a fitted evening dress. The glass of wine in her hand adds to the sophisticated feel.

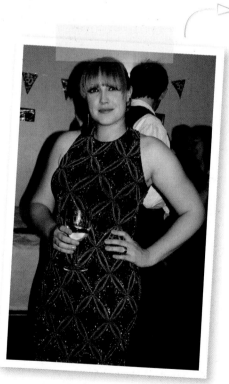

1 The pose in the photograph is great, but to add a sense of her interacting with the viewer, change her arm position so that it looks like she's offering a toast to the camera. (Use the template on page 83, if it helps.)

2 When adding in all the extra details, remember to fit the dress to her body closely. Note how her fringe skim her eyebrows and curves down at the sides. The rest of her hair is pulled back into a tight bun.

Final image

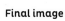

3 For a clean Seinen look, use thin lines and precise strokes. Avoid leaving gaps; try to close your lines cleanly wherever you can, and end any lines with a sharp taper. Define her bustline with a few creases of cloth.

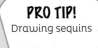

PRO TIP!
Drawing sequins

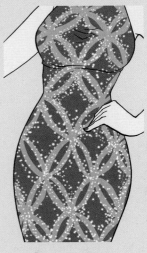

If colouring digitally, open a lower 4 layer and fill in all the areas of the drawing with flats in medium tones. For her dress, start with a dark grey flat, then draw a dark gold pattern on top, as in the photo. Use the line art layer to help keep your selections clean and to speed up the process.

If you want to add some sequins to the dress, add white dots on another layer in varying sizes all over it. You can either do this manually by dotting your brush all around, or you can adjust your brush settings to increase the spacing until they produce individual dots.

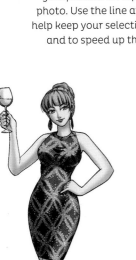

5 Add airbrushed shadows on another layer. Choose a setting like Shade or Burn to intensify the saturation by picking up the flats. Shade the edges of her arms and legs to emphasise their volume. Also, make an effort to shade the underbust and creases to give her a sensuous feel.

6 Add a final layer on top and set it to Addition, Luminescence or Dodge for saturated highlights. Add sharp highlights to her eyes, lips and hair, then soft airbrushed highlights to her cheeks, shoulders, bust, stomach and legs.

DRAW A DRIFT RACING CAR

Cars are very popular with young men, so it's no surprise that urban racing and car customisation feature highly in Seinen manga. Try taking a photo of your car and turning it into a cool drift racer!

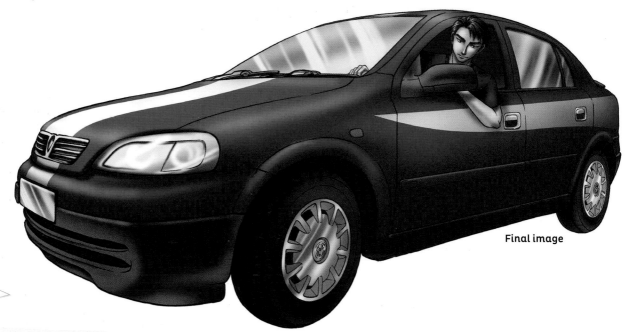

Final image

Photo source

Head out to your car and get a photo of it from a dynamic angle. Crouch down low and slightly to the front of it so that you can show off its shape and give it impact – as if it is thrusting out towards you.

1. It is perfectly acceptable for manga artists to trace or directly reference vehicles and buildings if they have a) taken the photos themselves, b) are pressed for time or c) want to get all the details absolutely right. Drawing a rough outline over the actual photo allows everything to be positioned properly. Then, insert a driver for context; having him lean out of the window gives him attitude.

Getting all of the details right is definitely the ② most painstaking part of drawing any vehicle. Using the photo as a reference, try to outline the key sections of the car and any visible joins. Don't ink any corners or vertices, as most modern cars have curves rather than sharp lines. You should hint at the car's volume during the shading stage. Make line widths thicker at the front and thinner towards the back.

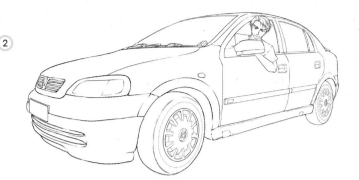

③ Try using the grisaille method of shading for maximum flexibility, which means completing all of your shading in greys on one layer. If working digitally, lay down a dark grey, add a layer mask and softly airbrush in highlights. Only use whites where you want there to be strong highlights, otherwise stick to light greys so that the image picks up the colour better in the next stage.

On a separate layer underneath, lay down some ④ flat colours in bright and fairly light shades. Now you can let your imagination run wild with the paint job! The car has become a bold, bright red, with white racing stripes over the front and sides. Toggle your previous shading layer off so that you can concentrate on filling the areas cleanly.

⑤ Now, make both layers visible and set the shading layer to Hard Light so that it picks up the colour layer.

PRO TIP!
Adjust your greys

Go back to your shading layer and tint the dark grey. Make it sepia for the warm-coloured areas (such as reds and the man's skin) and navy for the cool areas (like the headlights, white racing stripes and metallic spokes). Then, add highlights to the man's eyes and hair, and to the rounded parts of the car's front.

DRAW A COMIC STRIP: DEMON STRANGER VERSUS HUNTER

Seinen comics are sophisticated, with storylines that include many twists and turns, often in a contemporary setting. Believable and complex scenarios make use of realism to get under the skin of the reader, but it's also great to introduce some dark, supernatural elements to shake things up a bit, as shown in this example.

SCRIPT

PAGE 1

Panel 1: Long shot, quiet street, a man in a hoodie and a woman in a tracksuit are approaching each other on the pavement.

Panel 2: Mid-shot, they both pass each other closely.

Panel 3: Close-up, the hunter's eyes widen as she realises that the hooded man is not normal.

Panel 4: (In the background as she whirls around to confront him …)

HUNTER: Wait … hey, you there!

Demon is in foreground, eyes in shadow, smirking.

Panel 5: Extreme close-up – the demon's eyes have black sclera.

PAGE 2

Panel 1: Long shot, flashes of energy over the demon as he contorts and starts transforming into his true form.

Panel 2: Mid-shot, the demon turns back to look at hunter in true form.

Panel 3: Close-up, hunter holds her hand up as her hair starts to transform into a blade.

Panel 4: Close-up, her hand closes over a finished blade.

1 Scripting

As always, this begins with a real-world scenario that can be adapted to a Seinen situation. Keep it short so that it fits on one spread – a single encounter. Two normal-looking people pass each other on a quiet city street. One of them is actually a demon in disguise; the other is a demon hunter who realises this and calls him out on it. The demon then transforms, and the hunter powers up to fight.

2 Storyboard

A good script can generate a good storyboard and vice versa. When doing both, try to plan the action across the spread so that large panels are dedicated to moments of high impact and so that, visually, the camera angles and zoom are varied in adjacent panels.

2a: Include an establishing shot of the setting near the start. Use real-life street fashion to make your characters appear normal. Diagonal lines are great for creating movement, so they have been used in the second page as the action heats up.

3 Drawing and inking

Once you've refined your draft sketches, start your inks by filling in the details gradually and carefully. Seinen-style comic art is highly detailed with a lot of shading built into the inking process with hatching techniques. It may seem like a lot of work, but you don't have to make each line parallel perfect; the feel is often loose, gritty and dark, with organic-looking contour hatching that curves with an object's surface.

3a: Make sure that the level of detail is consistent from panel to panel, foreground to background. Add some texture and shading to the background of the city street, then spend the same amount of time on the hatching of all the lines and shadows on the close-up of the demon's face, as both panels are prominent.

3b: It is important to portray motion and stillness on this page. The first panel shows the demon in the process of transforming, so lots of vertical lines and spikes give an impression of movement, as if it's a motion blur. Next, the focus is on the still face while the extremities are in slight motion. The hunter's hair is the main thing that moves in the final two panels, so they are presented in very similar 'before and after' shots.

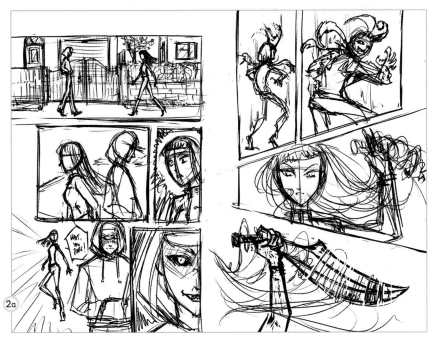

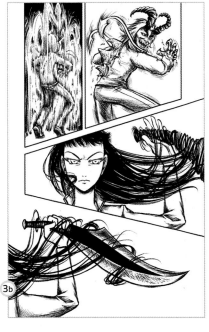

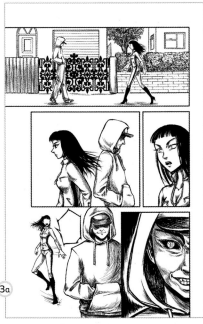

2a

3a

3b

PRO TIP!
Street scenery

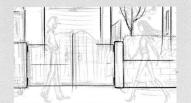

Drawing any background with buildings is tricky, but start with simple shapes – the main horizontal and vertical lines – to create a sense of scale.

There is no need to include detail everywhere in the picture, just focus on selected key areas to show the reader that you are capable of it! Add some noise texture to the hedge and the tree, draw in the brickwork lightly on the wall, and trace or copy some lace designs for the iron gate.

PRO TIP!
Trees

Always start a tree by drawing a trunk and its branches, as they will determine where the leaves go. Draw lots of uneven vertical lines along the branch to give the bark a rough appearance.

Try to draw clumps and groups of leaves, with only a few individual ones near the front to avoid wasting time unnecessarily. It's key to have some clumps in front, obscuring some of the branches further back.

④ Shading with screentone

It is important that the shading matches the inking. Large, low-density tones are too simple and cute to use with most Seinen comics because of their detailed hatchwork, so try to stick to very fine, small dot tones and noise textures. Where possible, go for patterns that look almost like organic ink lines.

4a: This page has a black background added behind the panels to darken the mood. Very fine screentone patterns are used in the background of the first panel for depth. A sliver of hatched lines is added to the second panel for a sense of unease. Then, a swirly, psychedelic pattern is used in the third panel to show the hunter sensing the demon's presence. Emphasis lines enhance the movement of the hunter turning round.

4b: Thin, curved lines have been added to the second panel for movement and energy. Cross-hatched swirls rise from below in the third panel to reinforce the rising power in the hunter as her hair transforms, but the last panel is deliberately left stark so that the reader's attention is fully on the revealed blade.

4c: The finished spread as a whole is an intriguing snapshot of a supernatural Seinen manga. You get the feeling that the hunter means business and knows what she's doing.

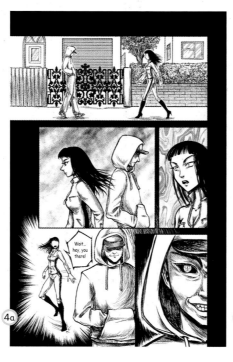

4a

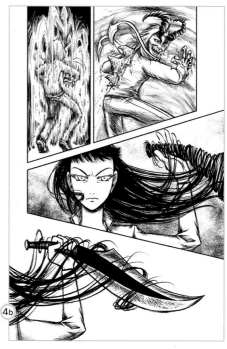

4b

PRO TIP!
Demon eyes

One of the easiest ways to make someone look unsettling and eerie is to change their eyes. Of course, the Seinen style of inking and shading as a whole is very detailed, but the main thing done here was turning the whites of the eyes black, and creating a lizard-like eye with a slitted pupil and jagged iris pattern.

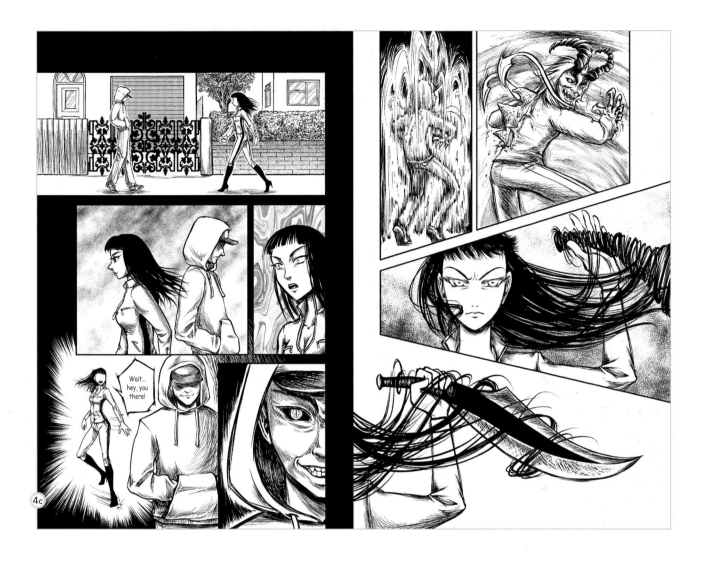

PRO TIP!
Fashion transformation

The demon initially looks like any guy you might encounter on the street, wearing a hoodie, baseball cap, track pants and trainers, with his hands in his pockets. But, you can use the clothes he is wearing to influence his demonic form. The cap extends into his horns, his hood becomes a mane, the drawstrings become bladed feelers, and the hands that were hidden are revealed to have huge claws.

SEINEN FIGURE TEMPLATES

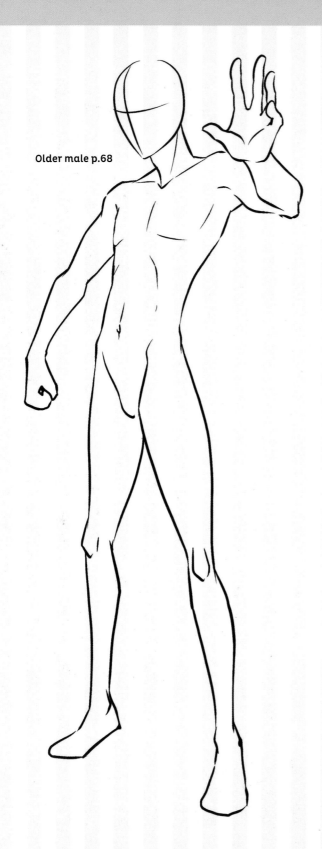

Older male p.68

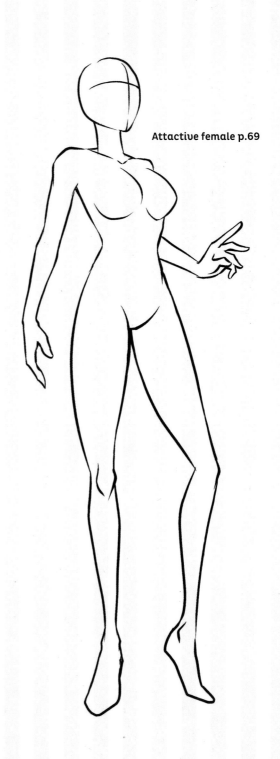

Attactive female p.69

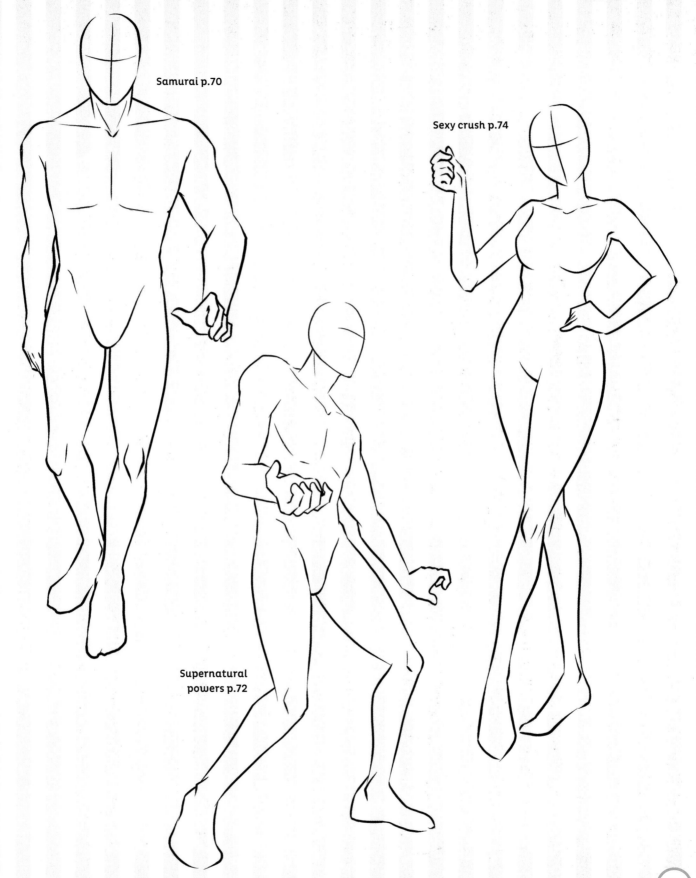

Samurai p.70

Sexy crush p.74

Supernatural
powers p.72

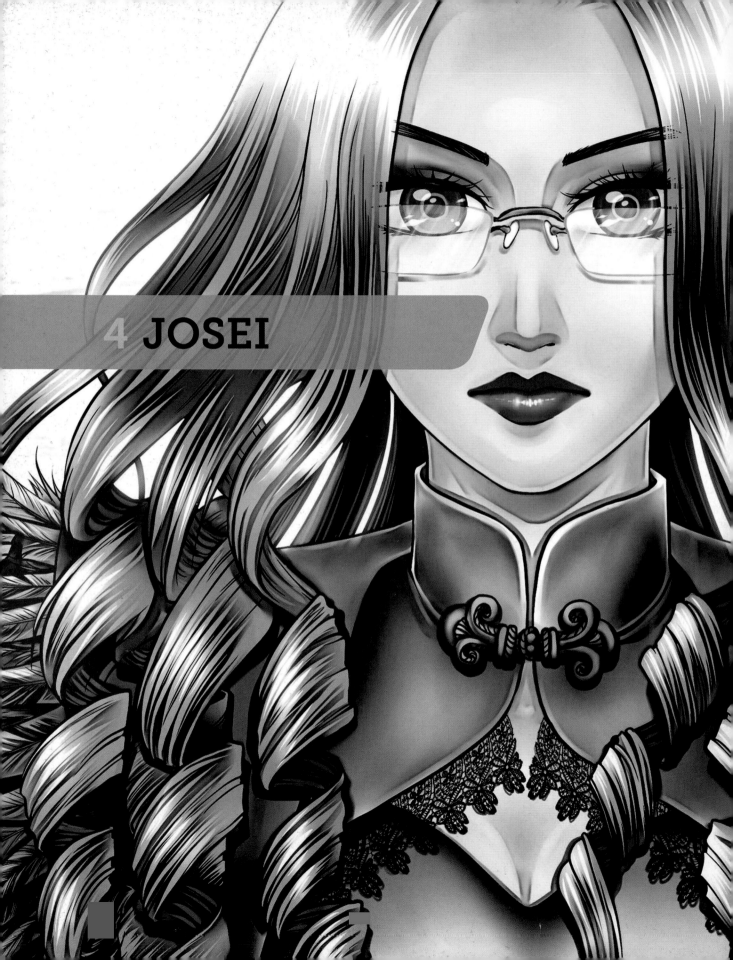

4 JOSEI

女性漫画

Josei manga is marketed at older girls and women aged 18 to 30. The majority of Josei series have a contemporary setting, with historical period dramas coming in a close second, and with very few fantasy elements. Like Seinen manga, it is much more gritty and realistic than Shoujo or Shounen.

JOSEI OVERVIEW

Relationships and character interaction are still the driving force of Josei manga, but mature audiences prefer much more complicated dynamics between friends and lovers. Class differences, cultural clashes and familial duty can come into play and drive rifts between people who are otherwise well matched. But, most prominently, relationships are tested by the characters themselves, who are never perfect.

The protagonist can be fatalistic, self-destructive and easily swayed by others. Friends can turn out to be villains, crushes can be unattainable. Love affairs may be conducted in secret despite all parties knowing that it is wrong, but unable to help their feelings. And, of course, Josei series will depict scenes that are sexual in nature, but usually in an abstract way rather than full shaded detail.

As mature audiences are less superficial than younger teens, Josei manga can come in a wide variety of styles, but there are some popular choices. Characters can be drawn like fashion illustrations with elongated limbs and rough colouring. Their designs are elegant, with stylish hair and clothes, and red lips to match. The finish is often impressionistic – thin lines with gaps, textures and patterns added only where needed.

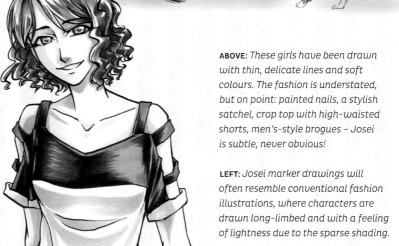

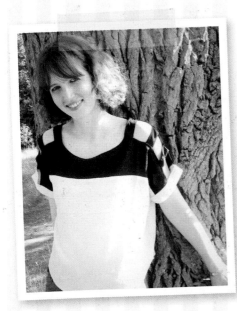

ABOVE: *These girls have been drawn with thin, delicate lines and soft colours. The fashion is understated, but on point: painted nails, a stylish satchel, crop top with high-waisted shorts, men's-style brogues – Josei is subtle, never obvious!*

LEFT: *Josei marker drawings will often resemble conventional fashion illustrations, where characters are drawn long-limbed and with a feeling of lightness due to the sparse shading.*

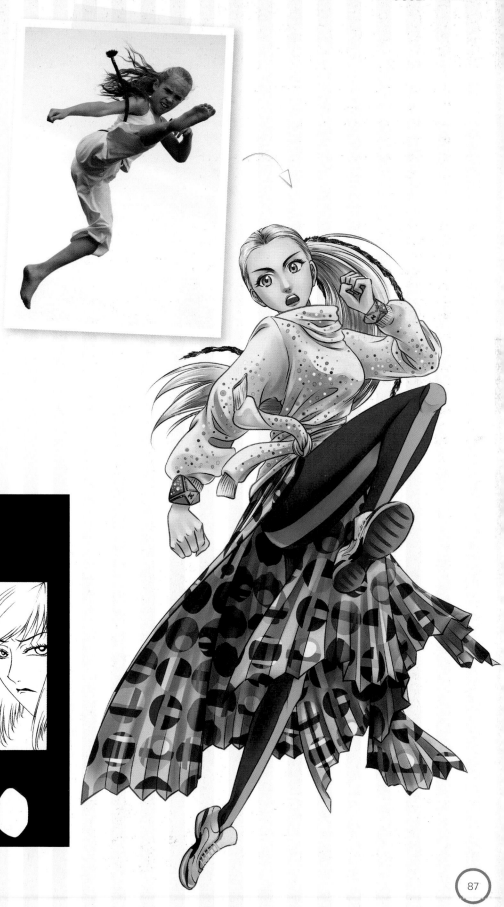

RIGHT AND BELOW RIGHT: *This artwork was inspired by an action photo, and the clothing was then drawn to match the prêt-à-porter line of a famous fashion house, so the beadwork and textile patterns were painstakingly researched. Note the subtle eyeshadow, lipstick and bracelets – these are much more common in Josei than Shoujo.*

BELOW: *This image is very stark. There's no shading, just black-and-white fills, and everything is drawn with clean, precise lines. But, it still feels Josei because of the characters' sharp features and bold hairstyles. The blonde woman's facial expressions – particularly her eyes and mouth – speak volumes.*

DRAWING JOSEI-STYLE CHARACTERS

Josei manga is aimed at grown women, so although the level of realism and the style of inking and shading can vary, it is always pretty and delicate. The artist's sense of style is given free rein, while storylines, though still focused on relationships, are far more complicated and mature. (Templates for these characters are on pages 100–101.)

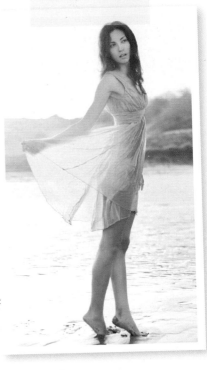

Female protagonist

Women are usually aged between 18 and 30 years old. They tend not to be as bright and bubbly as their Shoujo counterparts. It's far more common for them to be more reserved, jaded, on guard and even emotionally fragile due to painful histories. They often identify strongly with their profession in the series, as the story will follow how they juggle work, life and love.

Body type

Josei women resemble fashion illustrations: long and thin figures with visible bone structure. Aim for a high ratio of head lengths – eight heads tall or more.

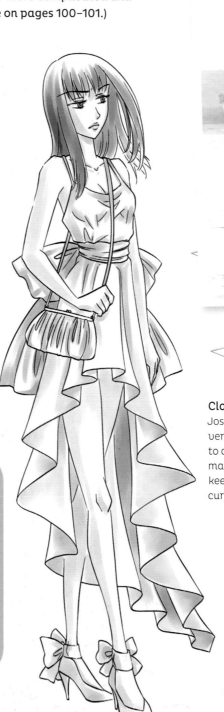

Drawing notes

Depict her cleanly and clearly, with minimal, abstract lines. Leave lots of gaps to add delicacy. The colouring style is also very soft and delicate, focusing on the shadows and leaving lots of white.

Clothing

Josei manga will often feature very stylish clothes and hairstyles to appeal to its readership. Study magazines for inspiration and to keep their looks up to date with current fashion.

The face

The challenge is to show a variety of soulful emotions. Conflict, indecision and inner turmoil feature a lot; they are more subtle than the basic emotions of happy, angry and sad.

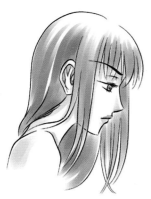

The profile

It's important to show the tilt of the top eyelash line and to manipulate the profile of her full lips for maximum control when depicting her emotions.

Male protagonist

Josei men are famously beautiful; tall and lean, but broad shouldered and lightly muscled. Sweeping eyelashes and perfect hair are offset by chiselled jawlines. Their personalities can be anything from sensitive to domineering, but they always leave the heroine wondering if they are 'the one'.

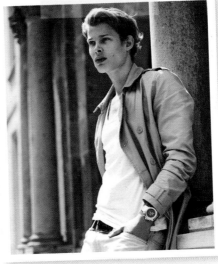

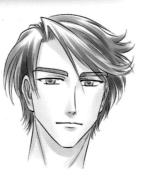

The face

Men tend to be depicted with smaller eyes and more extreme angular features, in both body and face.

Body type

Similar to Shoujo, Josei men have a tall, thin build. They are drawn even taller – ten heads is common.

PRO TIP!
A tight embrace

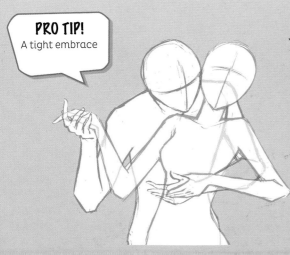

Josei manga is known for featuring hot, steamy scenes between couples, so it's important to practise drawing people closely interacting. Use pencils to draft both figures, including the parts that can't be seen, so that joints and limbs curve around bodies correctly.

DRAW A HIGH-FASHION SELF-PORTRAIT

Josei characters are often stylish, mature, independent men and women. They have strong personalities and tastes, so this is often expressed in their appearance – not only in the way that they are drawn, but also the clothes they wear. Here, I will show you the steps I took to create a self-portrait, which will hopefully inspire you to create one of your own!

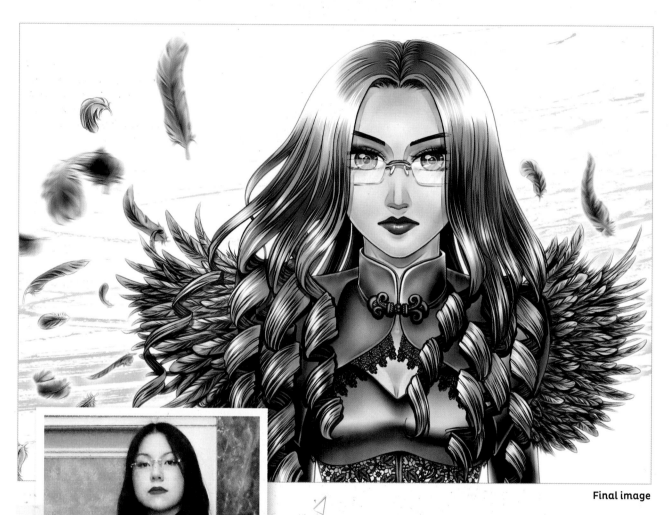

Final image

Photo source

I wanted to draw a self-portrait that was suitable for my age and showed off my love of fashion. I attended a Gothic Lolita fashion event and wore a very extravagant outfit – a black feather cape, lacey bolero and a gold satin and black lace corset! It was the perfect inspiration for a Josei-type drawing with lots of fine detail and in an elegant style that wasn't overly cute.

① Initial sketches

Use photos as references for clothes, hair and make-up, but don't let them restrict your drawing. Try out a few poses to see if you can portray the right sort of mood and show off the fashion. Also think about the purpose of your image. I wanted to use mine as a profile picture online, so I had to take this into consideration when choosing a pose. (If you want to have a go at recreating my portrait before moving on to your own, a full-figure template is on page 101.)

LEFT: *This sketch is soft and elegant, but the angle and the hair make it hard to see the neckline and details of the jacket. We also lose the impact of the feather cape.*

LEFT: *This pose creates a nice sense of mystery, but the front of the outfit is lost and the eyes are partly obscured by the glasses. If this image was reduced in size, the face would not be recognisable.*

BELOW: *This head-on pose with full eye contact challenges the viewer. It shows off the outfit details, and the swirling hair is like calm centred within chaos. It also crops and shrinks down easily.*

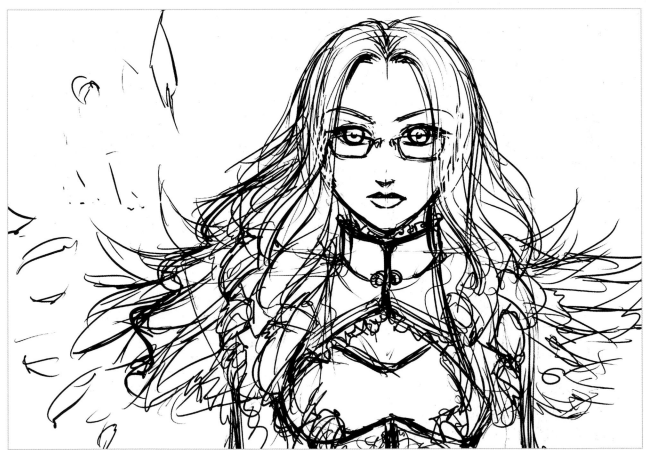

PRO TIP!
Blurring

Blurring is a great method for suggesting motion in your image. Photoshop has a filter for this that blurs your selection by the number of pixels you specify. If drawing by hand, soften the outline of the object and streak it sideways at a consistent angle. In the example above, motion blurring has been added to a puff of scattering feathers (see far right).

② Drawing

The process of drawing a Josei portrait requires careful choices. Whether you go for a simple rendition or something more complicated, the lines are placed precisely and each one has a reason for being there; the style does not use excess lines. As the subject matter is high fashion, this close-up portrait needs thin line art with lots of detail to show off the outfit. Use fairly thin pen nibs when inking, and draw with sweeping, confident strokes so that there aren't any wiggles in your lines. It may be painstaking, but stick with it!

Adding detail

Slowly refine your sketch and add all the details you need before inking, whether it's where each spiral of hair goes (see page 55), or every twist on the knotted button fastening.

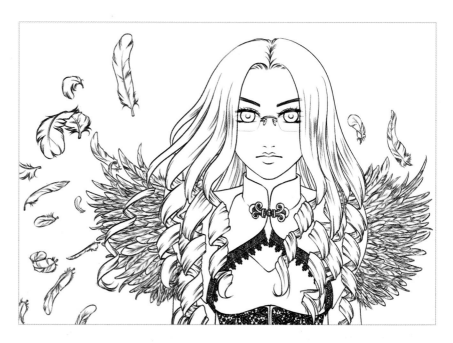

Creating depth and texture

Ink the objects that are in front first; these should have the thickest line weight. This lets you gauge where to fit objects behind, and it also makes your lines thinner the further back you go. Add in real clothing textures like lace by sticking it on as screentone or digitally layering it on top.

③ Shading and colours

Josei tends to be finished in one of
two contrasting ways. It can be very
simply shaded and coloured, perhaps
using a soft tint, block colours or a
few brushstrokes in the shaded areas.
Alternatively, it can be very intricately
finished to show all the creases and
textures. Simple shading, of course, suits
simple line art, but detailed lines can be
coloured in either style, as it sometimes
showcases the lines better if the line
art is very bold.

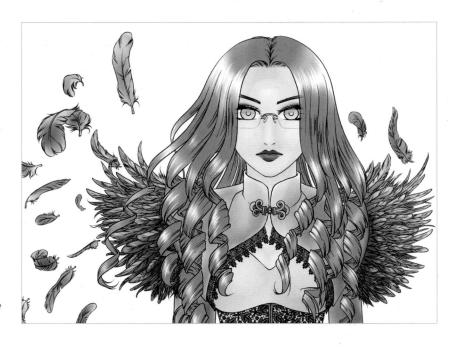

RIGHT: *This option features simple colouring
and shading – soft fills with airbrushed
shadows and highlights. The line art can be
seen clearly, but the lines are very thin, and
the feather details are incongruous with the
more open areas.*

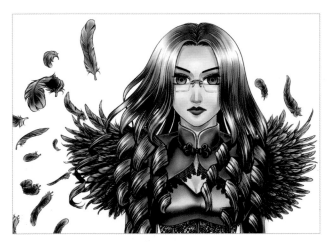

ABOVE: *This detailed shading, particularly
on the hair and feathers, distributes interest
around the picture. The lighting is from
the front, as if in a studio, so the figure is
brightly lit, and the shadows show off
shapes and textures.*

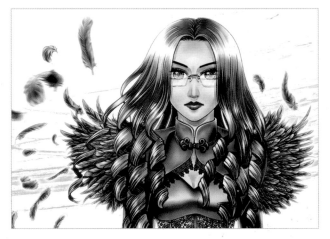

ABOVE: *My chosen version has a glowing
backlit effect, with extra highlights on
the glasses and eyes, iridescent tones
to the blacks, streaks of colour in the
background to mirror a gust of wind,
and motion blur to some of the foreground
feathers (see the Pro Tip box opposite).*

DRAW YOURSELF AS A GEISHA

Japanese period drama, or Jidaigeki, is a perennial favourite amongst older audiences of manga, due to the romance and chivalry of another age, forbidden love between people of different classes, and more. So, beautiful courtesans like geisha appear fairly often.

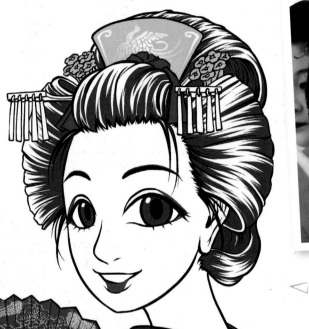

Photo sources
Our reference (above) has ideal geisha features – round face, lidded eyes, full lips and thick hair. A photo of a geisha then provides the details of the hairstyle.

①

To focus on the make-up and hair that is so characteristic of geisha, try a mid-shot zoom pose. The nape of the neck is considered very alluring, so having her back towards us is ideal. A folding fan is also an authentic accessory. (A full-body template is on page 101.)

Final image

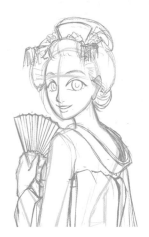

②

Try to draw any identifiable facial features without using too many lines. Concentrate on the highly sculpted and decorated hair bun and the components of the kimono and the obi belt. Do your research and study lots of photos to get it right. The 'maiko' rank of geisha is the most flashy of them all, so this is the look to go for.

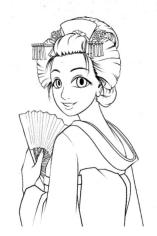

③

Josei manga style can be very detailed, to show off clothing and accessory design, but it is always very minimal and clean, too. Use single lines to depict everything – no hatching or anything messy. Connect your lines neatly and thicken them only where needed.

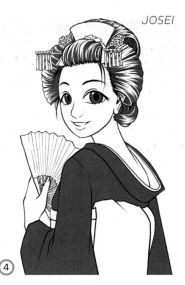

④

Black kimonos are seen as the most formal, so tie that in with the blacks in the hair and eyes. Use streaks in the hair to give the impression of sleek, shiny, combed hair. Keep the highlights in the eyes small for an elegant feel, rather than making her look overly cute.

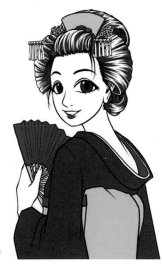

⑤

Spot colours can be very effective, particularly because geisha are well known for their use of white face paint and bright red make-up. Red is a key accent colour, so use it throughout. Paint the outer corners of the eyes, the iconic lower lip, the fan, the ribbon in the hair, the sash lining, the obi belt and the inside of the 'hadagi' (inner kimono). Use gold for the rest of the image.

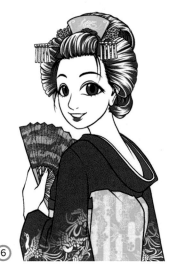

⑥

Kimono outfits are known for having beautiful patterns on the sleeves and belt, so add masks to the layers of colour, and try painting in or overlaying some traditional Japanese patterns. Motifs like flowers, plants, insects and birds are common.

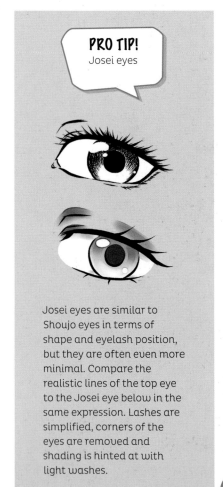

PRO TIP!
Josei eyes

Josei eyes are similar to Shoujo eyes in terms of shape and eyelash position, but they are often even more minimal. Compare the realistic lines of the top eye to the Josei eye below in the same expression. Lashes are simplified, corners of the eyes are removed and shading is hinted at with light washes.

DRAW YOURSELF AS A FAIRY-TALE PRINCESS

Josei manga will throw the protagonist into all sorts of beautiful, elegant yet socially demanding situations; whether it is a real-life setting or fantasy, it is a wonderful opportunity to dress up your character. If you have a photo of yourself with a wig on, why not go all the way and turn yourself into a full-blown fairy-tale princess?

Photo source
Our subject is wearing a beautiful pink wig with flower accessories. Her top has ribbon lacing, so perhaps this can inspire a ball gown?

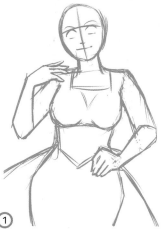

①

This rough sketch is strongly inspired by the photo – an elegant princess looks around her with a gracious, wide-eyed expression. Keep the raised hand on her hair for a delicate pose. (If you want to draw her whole body, use the template on page 101.)

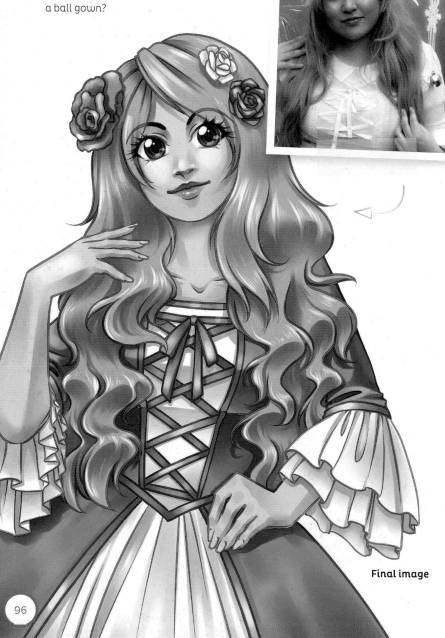

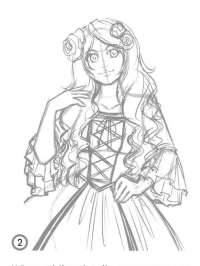

②

When adding details, concentrate on capturing the voluminous, wavy hair. Ball gowns are big and puffy in places, like the sleeve hems and the skirt, but keep the bodice tight for contrast.

Final image

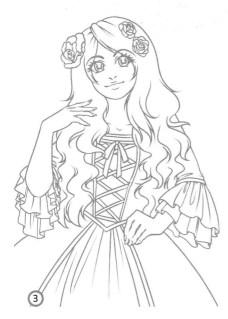

③

The finished picture is going to have a lot of detail, but soft painted colouring, so the lines are in sepia; they are fairly thin, with lots of gaps and tapered ends for delicacy. Put some effort into the ruffles, pleats and folds to create a sense of opulence.

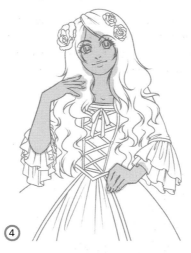

④

When painting digitally, always start from the back, then paint things on top. The skin is almost always underneath everything. Paint a medium shade on a layer underneath the lines, then lock the transparency so that you can shade freely without making more mess.

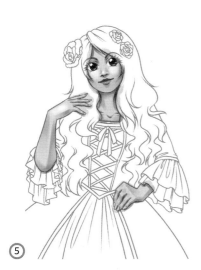

⑤

Add shadows around the edges of her face and towards the bottom of each arm, so the lighting roughly comes from above and is fairly diffuse. Add more detail with highlights, add lipstick and work on the eyes.

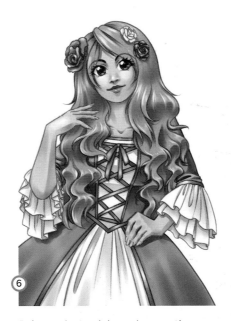

⑥

Paint each remaining colour section on top, one at a time. Use the line art to help guide you, and make selections to paint within, or separate them into layers to lock the transparency.

PRO TIP!
Ready for the ball!

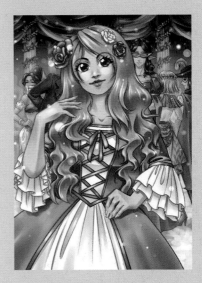

Now that your princess is dressed and ready, why not send her to a ball? Paint in a multi-coloured wash as the background and use light strokes to paint columns covered in winding leaves.
You will also need to draw some background characters in formal attire so this will all take time. Paint them into another layer, then make it slightly translucent so that they pick up more of the general lighting and blend better. Finish by adding glittery sparkles throughout.

DRAW A COMIC STRIP: ON–OFF RELATIONSHIP

In Josei manga, relationships are shown in all their grey, gritty glory. It's never perfect and clean. Things are always complicated, but passionate, and full of drama and unexpected turns. So, if you're going to draw a Josei comic, it seems appropriate to show lovers who aren't really a couple. Or are they? It's anyone's guess!

① Scripting

When you're writing dialogue for a more mature audience, as with Josei, don't treat your readers like children. They can infer a great deal from what is being said and the expressions on the characters' faces. Hint that the leading lady is never sure whether the man is coming or going.

SCRIPT

A stylishly dressed woman is chopping vegetables in the kitchen.

JAMES (letting himself in through the door): Hello darling. How are things?

CAROL: Oh, it's you. Why are you so late?

JAMES (tilts Carol's face up to his): Does it matter?

He kisses her.

CAROL (exasperated): You were supposed to help me with the cooking.

JAMES: I know. But at least I can help with the dishes?

② Storyboard

Josei manga will often show a series of panels that showcase close character interaction without changing the camera angle or zoom too much. This way, you can really see the progression of their faces and poses.

2a: The scene is set with the woman chopping vegetables. The camera is kept fairly consistent to show the progression of how the man pulls her into a kiss. Drawing the hands well is important; they are very expressive and prominent in this scene.

③ Drawing and inking

Start adding in the details of the surroundings to create context and make what is happening clearer. Fill the kitchen with more utensils, and really flesh out the characters' clothing and expressions. When inking, keep your lines light and consistent.

3a: Pencil in the details of their clothing to add realism. The woman's blouse puffs out slightly before being tucked into her skirt. She also wears a necklace, which adds context in the third panel. The man's cuffs and collar need to be right, too.

3b: Use a fineliner with a thicker nib for the speech bubbles and panels, then switch to a fine nib for the rest of the inking. For lipstick, ink in her lips, following the natural lines and creases.

3c: Resize to final print dimensions. Add the lettering and make any further corrections to the artwork before converting to pure black and white, ready for shading.

④ Shading with screentone

Josei manga is very minimal in tone, relying a lot more on black fills and white spaces. The characters have a lot of room to breathe, to match pauses and silent glances. Tone only what you need to – mostly clothing patterns.

4a: The clothing is patterned and coloured, but everything else is left quite stark. In the fourth panel, the background is pretty, but it is angular and cross-hatched with dark smudges to create a bittersweet mood.

PRO TIP!
Speech bubbles

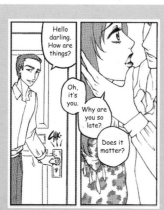

Speech bubble presentation requires as much consideration as panel layout. Multiple joined circles break the dialogue up into natural pauses. Overlapping one bubble over another indicates that another person has started speaking, almost cutting in.

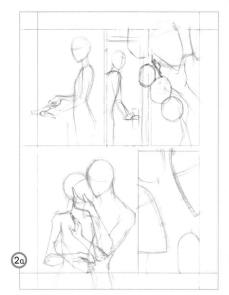

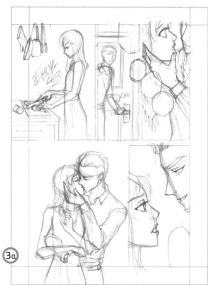

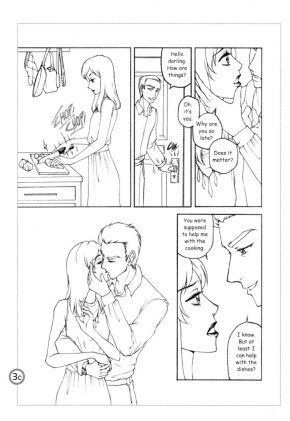

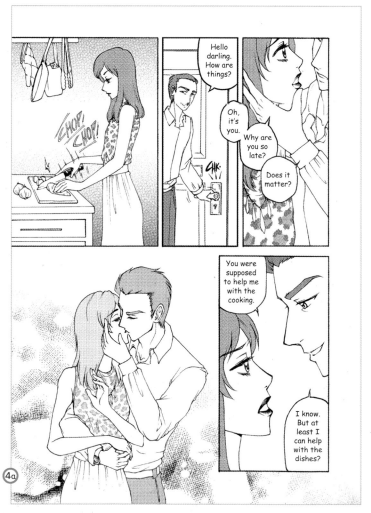

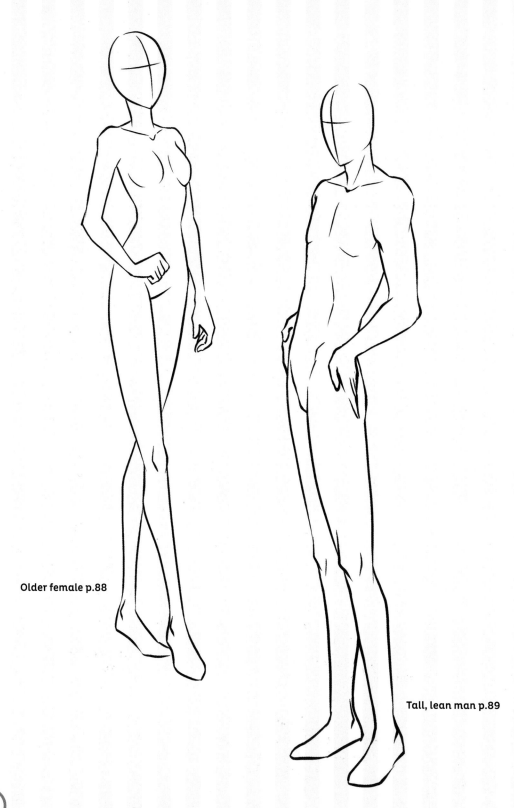

Older female p.88

Tall, lean man p.89

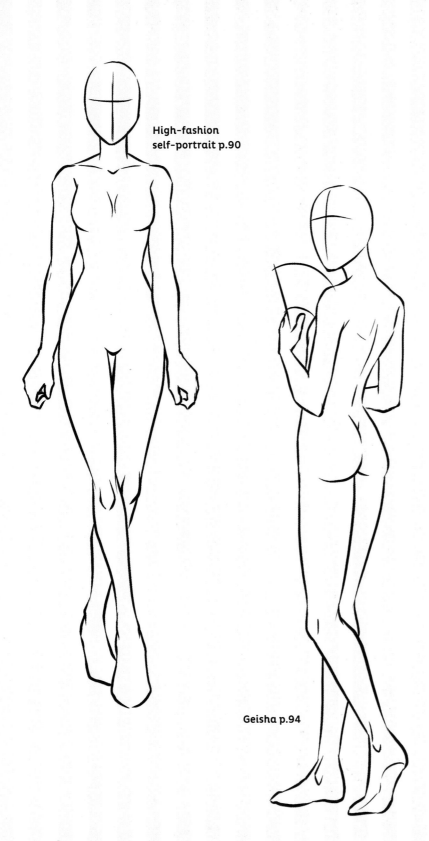

High-fashion
self-portrait p.90

Geisha p.94

Fairy-tale princess
p.96

5 KODOMO

子供向け漫画

Kodomo manga, otherwise known as Kodomomuke manga, translates as 'manga directed towards children'. There is some crossover with Shounen and Shoujo manga, but it is aimed at even younger audiences, so there is a strong emphasis on good behaviour and morals.

KODOMO OVERVIEW

Kodomo settings are usually contemporary, but with some fantasy and sci-fi. There is often a mixture, as many popular series will have real settings, but include characters with special powers or amazing pets. And speaking of pets, animals are favourites; sometimes they are the lead characters!

Kodomo manga usually follows one or two young characters as they go about their daily routine, and any little adventures they have along the way with friends and family, such as rescuing a cat from a tree, helping with grocery shopping, preparing a school project, going on holiday, and so on. They are meant to be easily understood and digested by young children, so they are generally episodic, with a firm moral message in each chapter.

The style of the artwork is bright, bold and simple. Faces and body proportions are simplified and rounded off. Colours are strong, with lots of flat fills or simple washes. If there is any shading at all, it's usually quite basic – one level of shadow or highlight, no complicated backlighting.

OPPOSITE: *This group shot of a Kodomo manga series shows all the characters at once! Their poses and outfits reflect their different personalities. Note the mix of sharp and rounded shapes in the hairstyles, too.*

RIGHT: *The girls in this football team have fairly realistic proportions, but are simply inked and coloured, with bright fills and sharp shadows. It's important to give characters distinct personalities if they are all wearing the same uniform.*

BELOW: *Even characters who are traditionally quite scary can be drawn in a Kodomo style. Here, a samurai is sharing his lunch with his animal companions. Everything is rounded off and chunky, with simple lines and watercolour fills; eyes are just circles, dots or lines.*

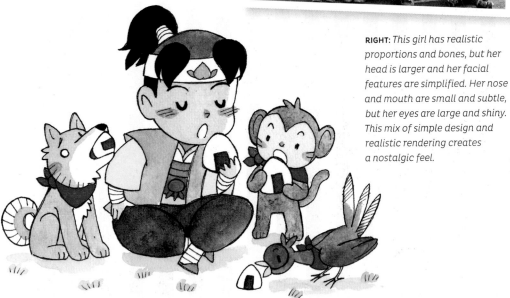

RIGHT: *This girl has realistic proportions and bones, but her head is larger and her facial features are simplified. Her nose and mouth are small and subtle, but her eyes are large and shiny. This mix of simple design and realistic rendering creates a nostalgic feel.*

105

DRAWING KODOMO-STYLE CHARACTERS

Kodomo manga is aimed at young children, so it has to be age appropriate and eye-catching. Characters are usually cute, with strong, simple designs that are easy to recognise. The roles they play are clear-cut, and storylines tend to teach good morals. (Templates for these characters are on pages 120–121.)

Children

Children are almost always the main characters of any Kodomo series. Young boys and girls – under 12 years old – are the norm so that young readers can relate to them. Try to go for a cute video game aesthetic; chunky designs with blocked-out sections of colour work well. Fairly thick, even outlines keep the look simple.

Body type and clothing

The height and body shape of both boy and girl are nearly identical – there are few differences in their silhouettes at this age. Choose poses and clothes that reflect their personalities, too. The girl's open stance, for example, displays her confidence, and her shorts make her seem active and ready to get her hands dirty.

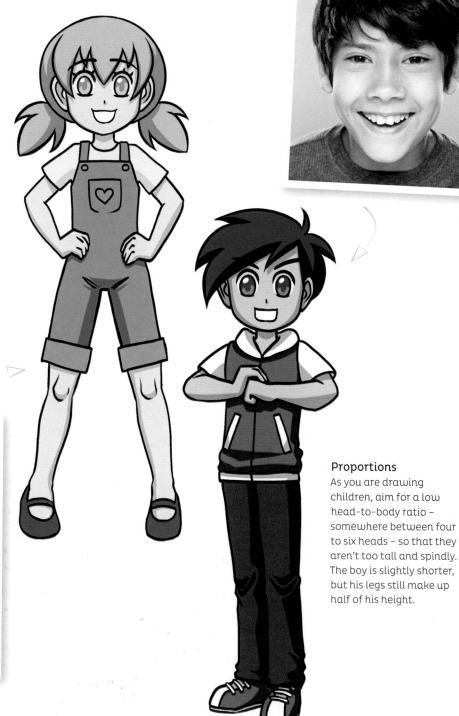

Proportions

As you are drawing children, aim for a low head-to-body ratio – somewhere between four to six heads – so that they aren't too tall and spindly. The boy is slightly shorter, but his legs still make up half of his height.

The boy's face

Eyes are simple and round, with no added details, and hair is just a few strong spikes. The colouring style matches the line work – sharp cel-art shading in bright colours.

The girl's face

The girl's hairstyle – pigtails – is both cute and practical. Stylewise, it provides a strong silhouette from the front and side, making her easily recognisable. Keep the spiked ends of her hair minimal; just draw a few key groups and clumps.

Adults

As children are often the protagonists of Kodomo manga, adults tend to be supporting characters in the background, providing advice and plot points to drive the character development of the leads. Even if you are drawing adults, that doesn't mean you can add loads of detail or switch art styles. Remember, always keep it simple and iconic.

Face and clothing

A parent or guardian is a frequent Kodomo side character. This woman's face and eyes are very similar to the girl's, but her face is a bit longer, and her hairstyle is more grown-up. She is clothed very simply in a lilac dress, apron and sensible court shoes, which suggest she is a practical mum.

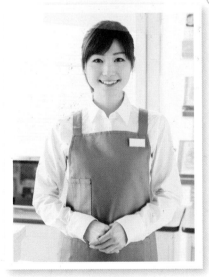

Pets

Animals are very popular in Kodomo series, acting as incredibly cute supporting characters in most cases, but they do occasionally play the lead, too! They are usually cute and charming, sometimes with lots of human expression in their faces.

LEFT: *Lots of clumps and bumps make this dog look soft and cuddly. Its small eyes and nose give it a delicate, pretty look, too.*

DRAW YOUR COUSINS AS ADVENTURERS

Grand adventures feature in a lot of Kodomo manga comics. Friendship and camaraderie are often important themes in these journeys, too, so where you find one adventurer, you'll likely find a whole bunch of friends backing them up!

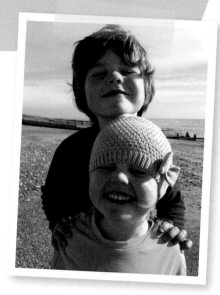

Photo source

The two children in this photo look like they would have each others' backs on an adventure, so let's give them some gear to help them on their way.

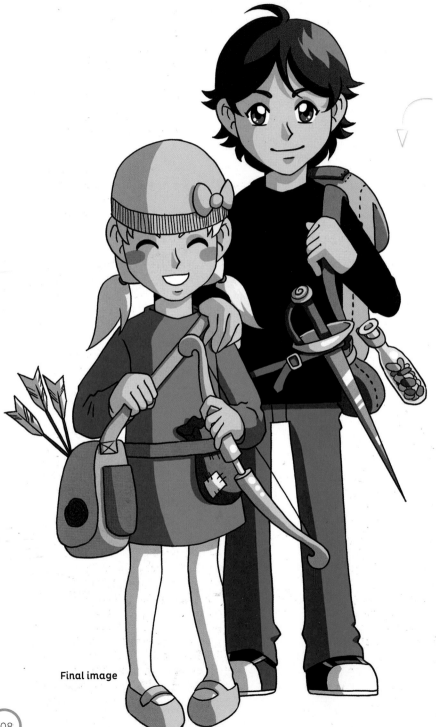

Final image

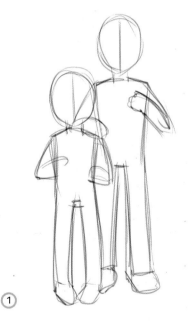

① Because there are two kids interacting here, a loose sketch helps establish placement. If you want to try out different poses, draw them on a separate piece of paper, then pick the one you like best. (Or take a shortcut and use the template on page 121!)

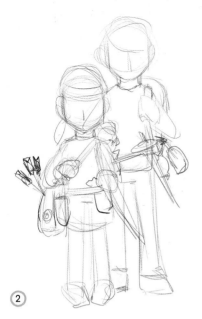

(2)

Start sketching the shapes that identify them – the girl's hat, the boy's hair. Kodomo style is very simple, so don't add too much. Then, try adding some props, like backpacks, a sword and a bow and arrow.

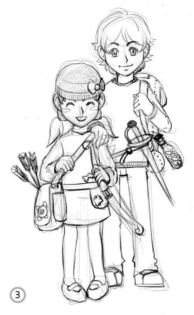

(3)

The next sketch uses the previous one as a guide, but it has much more detail and definition. The sketch from Step 2 is shown underneath in blue so that you can compare the two.

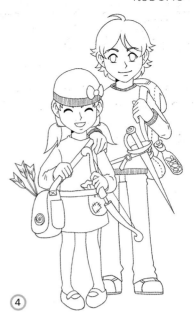

(4)

After so many sketches, the inks clean everything up – especially the small details like the coin bottle on the backpack and the bow and arrows.

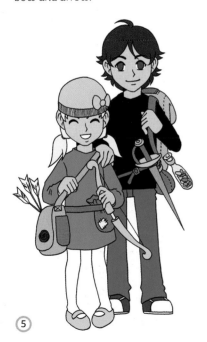

(5)

Now, apply the base colours. The kids have a whole bunch of accessories, which have been colour-coordinated to match the outfits they're wearing in the photograph.

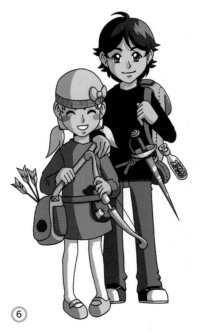

(6)

The shading is the final step. Add some simple white highlights here and there, picking out the shine on the sword and the bow for that little extra bit of polish.

PRO TIP!
Accessories

Whatever type of adventure your characters are going on, they'll need some accessories to get them through it. Whether these are small weapons, magical stones or even something as ordinary as an umbrella, they still have to be appropriate for children to use. This is a great opportunity to add a little more creative flair to your designs, too.

DRAW YOUR LITTLE BROTHER AS A ROBOT

Being a robot in Kodomo manga is pretty fun. Whether you can fly, transform or shoot lasers, there's bound to be adventure in store. When you're creating your robot alter ego, let your imagination run free – this is the future, after all!

① Why not get your subject to strike a dramatic pose that captures his personality? (The template for this superhero is on page 121.)

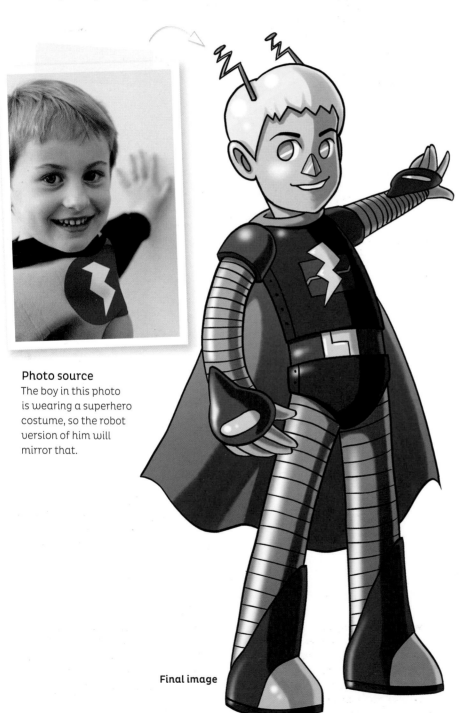

Photo source
The boy in this photo is wearing a superhero costume, so the robot version of him will mirror that.

Final image

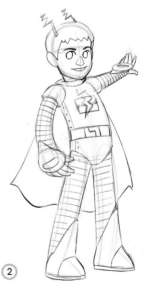

② Robots in Kodomo manga have more play with shapes and colours, so you don't have to be completely realistic with the anatomy. This robot has bendy telescopic arms and legs, which is fun when aimed at children. His boots and hands are chunky, too, and created with simple shapes.

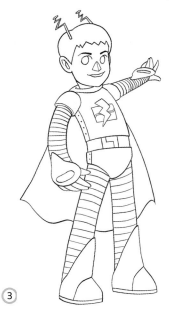

(3)

Keep your inking clean and bold to complement the simplicity of the design. This is where you tighten up the small details of your sketch. Note especially the arms and legs, which have lines across them curving according to their angle and shape.

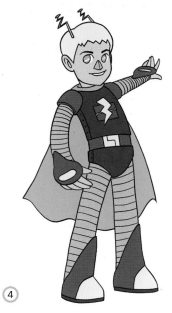

(4)

The base colours here are a mix of primary colours. These make him look like a good guy, right? These colours were mostly chosen to match the boy's blond hair. If you're drawing a group of people you can do fun things like colour-coordinate them all to create a whole team of superhero robots!

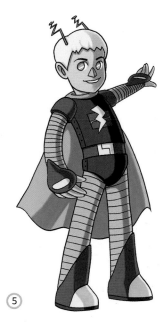

(5)

Now add the shading. See how it stops just before the edges? This is a simple way to shade a faux metallic look – as if the surface is so shiny that it's picking up a little light from behind, too.

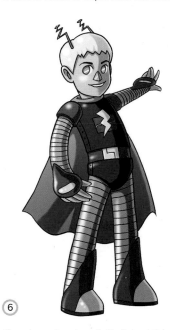

(6)

If you're colouring digitally, adding a couple of gradients on a Multiply layer with low opacity can add extra depth to your drawing. You can also achieve this effect with natural media, but you have to do it first, and then work the base colours and shading over the top.

PRO TIP!
Fun features

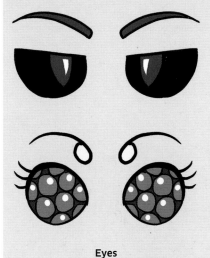

Eyes

Antennae

You could try being much more abstract and playful with facial features than in the example shown here. Here are a few alternatives you could try for eyes and antennae.

DRAW A MAGICAL BUS

In Kodomo manga, sometimes animals are your friends, and sometimes they are your transport! You might find mythical creatures or just regular common pets drawn with a twist, aiding the characters on their journey. You can add the same magical twist to your own pets with just a few simple touches.

Photo source

In this photo, the dogs are relaxing together. Not exactly how you want a bus to behave! So, if you need to, find some additional pictures of dogs running to help you construct a more dynamic sketch.

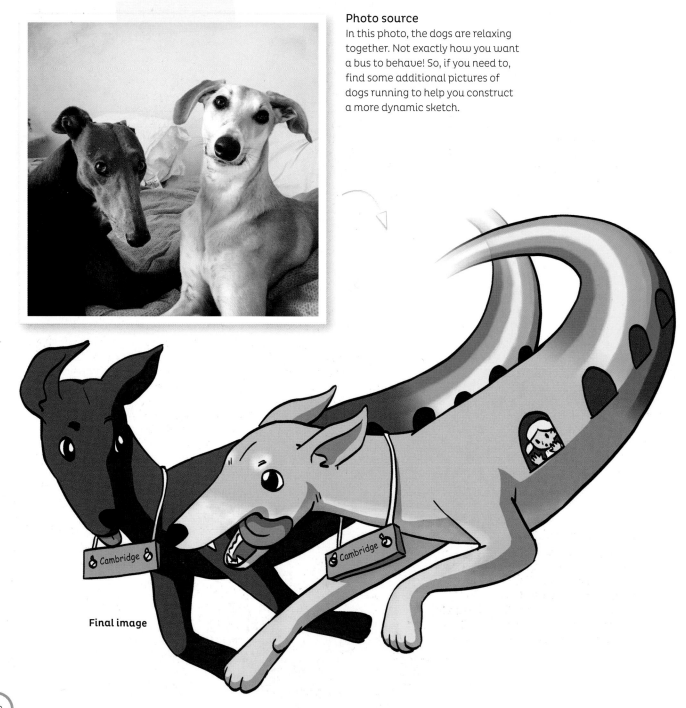

Final image

① Greyhounds love to run, so these dogs are shown having a race. Try to think about your pet and its personality. If it likes to sleep, maybe it'll be a cuddly – but always late – little puppy/kitty car. If your pet is older and slower, a more cautious pose might be better. (For this pose, see the template on page 121.)

We're skipping ahead a little ② here. The inks and some of the base colours have now been finished. You will see that the dogs are only coloured halfway along. There's a special reason for that.

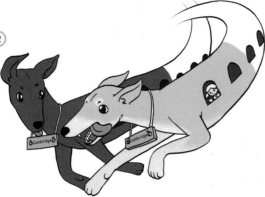

③ Now, the back of the dogs fade into rainbows. Because greyhounds have a deep chest and a tiny stomach, having them stretch out into a rainbow is a way to increase their length, making them more bus-like. The end of the rainbow fades to white, too, to make them even more ethereal and magical.

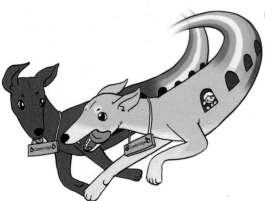

The last step is the shading. ④ A greyhound's fur is quite short, so the shading should follow the contours of its muscles rather than its fluff. If your pet is fuzzier, don't forget to shade with that characteristic in mind.

PRO TIP!
Using different animals

You don't just have to stick to the ground! Pet birds can transform into flying machines. Mice, squirrels, chinchillas and similar animals make great climbers. Think of the way different animals move, and use this to create different types of vehicles and riders.

Like the greyhounds with the rainbows, don't be afraid to make magical additions to enhance your designs either – wings, horns or extra legs are all common in manga.

DRAW YOUR FRIENDLY DOG

Because children love them so much, no Kodomo manga is complete without a few animals, whether they are from the farmyard or out in the wild. Animals provide a different point of view to human characters, and sometimes they even end up playing the starring role. The challenge with drawing animals in Kodomo manga is to capture their essence in a cuter, simpler form.

① Photo sources

A beloved family pet is a great resource for practising Kodomo style with animals – you will have infinite opportunities to observe their bone and muscle structure, understand the way they move, and capture their personality. Sketch from real life as much as you can, but also grab a few photos to study closely. This is Biggles the dog. A cheerful and inquisitive little guy, he loves sticking his nose into everything and looks very handsome in a bow tie.

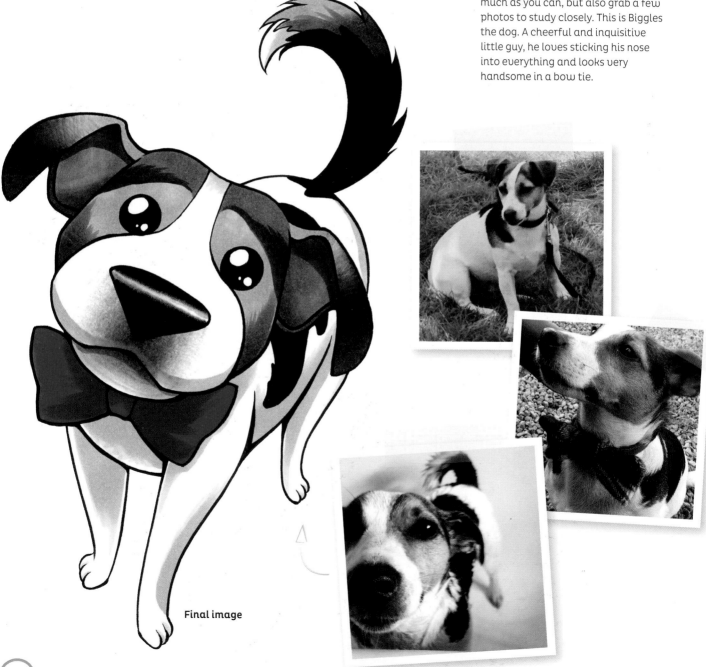

Final image

② Sketching

Use any photos you have to practise sketching so that you get used to drawing your pet. It can be harder than you think. Break it down into simple ovals and circles, and really observe the length of the limbs and where the joints are placed. Once you've tried sketching in a realistic style, try pulling back the detail and exaggerate any key features. Think about whether your pet's personality works with the style you've gone for. (For a full template of Biggles, see page 121.)

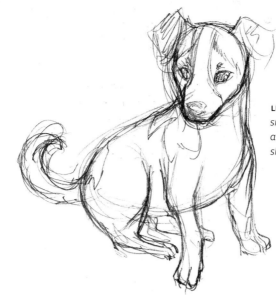

LEFT: *Biggles's head is quite small and his body is compact and rounded. He also has very short legs!*

RIGHT: *The shape of the body has been simplified here, and the legs are slimmer. The nose is smaller and the eyes are larger, but these changes make him look more like a cat or fox, which doesn't quite suit him.*

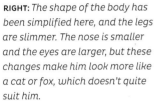

RIGHT. *This sketch captures the shape of Biggles's head, where the skull swells above the eyes. His folded ears are distinctive, too.*

RIGHT: *The outlines here have been smoothed and kept very simple, but the proportions have changed – the nose is bigger and the eyes are small, bright dots. This feels more true to his character.*

③ Drawing the final portrait

Once you've figured out how to stylise your pet, use a pose that shows off his or her character. Is he sneaky? Playful? Aloof? Lazy? It can even be funny to put one animal in the typical pose of a different animal – imagine a horse sitting down and begging like a dog! Remember to tackle the work in stages: draft lines first, then ink your final lines before removing the draft lines and adding shading in a style that is consistent with the drawing.

Combining references

The first photograph of Biggles putting his nose into the camera has a lot of personality, and his bow tie in another photograph looks very cute, so let's combine the two. This pose and style makes him look inquisitive and eager to please.

Keep it simple

Clean, bold lines work best for Kodomo style; they are easy for a child to process and recognise. Use smooth strokes, and keep the detail minimal – it's all about the shape and volume.

Colouring in

Bright colours and distinct shadows make this doggie pop right off the page! Start by adding some shadows on the legs and belly with a few brushstrokes. Darker areas of black, red and brown should then be filled in flat, leaving everything else white.

PRO TIP!
Animal eyes

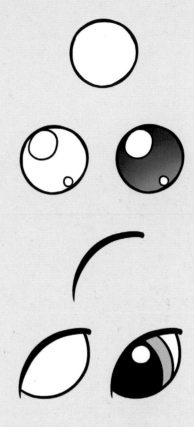

Finishing touches
Finish by adding a little more depth and contrast. Match some of the darker patches of brown on the coat and ears, and add extra shadows on the bow tie. Use simple brushstrokes or gradients. Keep the colour palette limited so that it feels clean and basic.

For Kodomo style, keep eyes simple and basic. Use the overall shapes found in real life and distil them to just ovals or triangles. Try putting in highlights and a gradient to add a sense of cuteness to a round, black eye. For a more mysterious look, use an oval or a triangle outline so that the whites of the eyes will show. Then, draw in the iris and a large pupil with a highlight.

DRAW A COMIC STRIP: DROPPING A BIRTHDAY CAKE

Themes in Kodomo manga vary wildly, from epic adventures to the day-to-day drama of everyday life. No matter the setting, though, friendship and family are always important themes. In this short, one-page comic we'll create something sweet and domestic.

① Scripting

The script is where you start to play with ideas. At this point, you're bound by nothing but your imagination and the page limit! If you get stuck, or feel like your script isn't flowing, don't be afraid to rewrite it or chop it up and move text around.

> **SCRIPT**
>
> *Child prepares to decorate her cake.*
>
> *CHILD:* Candies and sparkles!
>
> *Cut to decorated cake, with a lit candle in the centre.*
>
> *Child carries cake to her mum.*
>
> *CHILD:* A perfect cake ... made for mum!
>
> *Child trips and the cake goes flying through the air.*
>
> *CHILD:* Ah!
>
> *Mum is presented with the cake, bottom side up.*
>
> *MUM:* Ooh, my favourite! Upside-down cake.

② Storyboard

The cast of this comic is a mother and her daughter. As it's a Kodomo manga, it makes sense to make the daughter the star, as the audience can relate more to her.

2a: The story of a girl decorating a cake and then dropping it could have been plotted equally well over a couple of 'yonkoma' (four-panelled layouts). However, drawing it as a single page will offer you more freedom – the panels with the cake flying and landing add a little visual excitement because their borders are at dynamic angles.

③ Drawing and inking

For the inks, draw the panel borders first, then the speech bubbles, then the characters and props.

3a: To keep everything to a single page, keep the focus on the characters, not the backgrounds – there is no point wasting time establishing the setting if it's not needed for the joke.

3b: Now add the lettering and sound effects. It's useful to add them early, just in case you need to make any adjustments to the size of the speech bubbles.

④ Shading with screentone

Try to limit your screentones and keep them basic; this will keep the art easy to read.

4a: Use a few flashes here and there for dramatic effect (like the speedlines around the cake), but overall, keep the toning nice and simple.

PRO TIP!
Kids will be kids

Kodomo characters are aspirational figures—they often do things that children their age wouldn't be capable of in reality. No one is really going to let their 10-year-old child go on wild adventures across the world, but it's a common plot in manga. However, even if the characters are doing things beyond their years, they are still children, and they display their immaturity in different ways: emotionally, intellectually, or through playfulness.

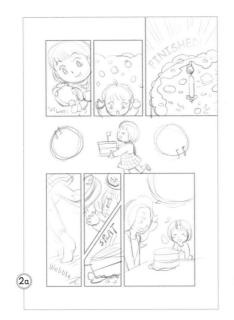

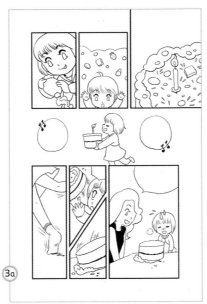

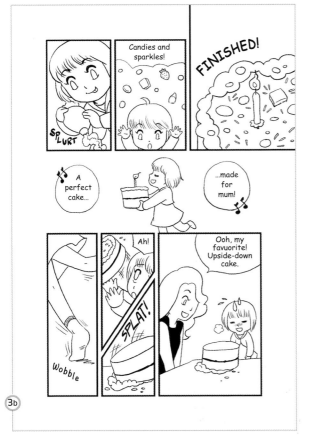

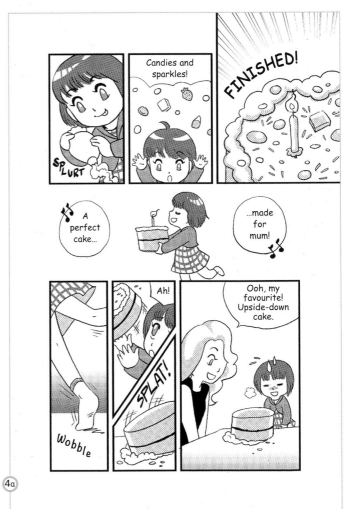

KODOMO FIGURE TEMPLATES

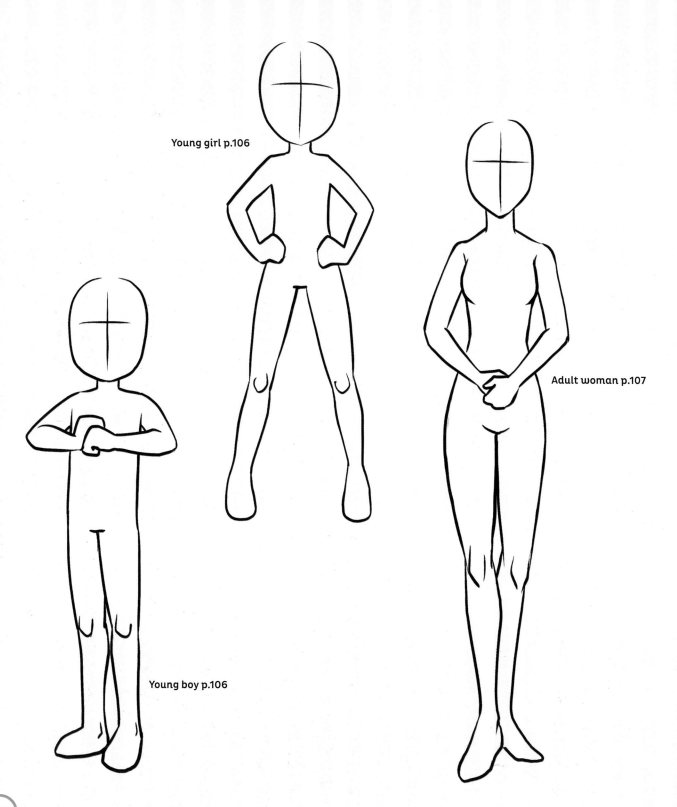

Young girl p.106

Adult woman p.107

Young boy p.106

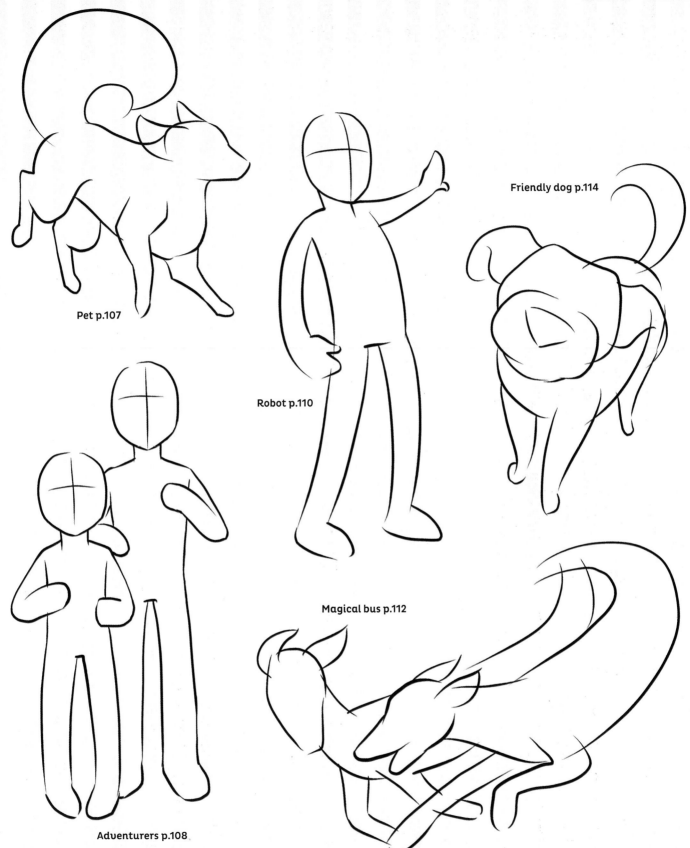

Pet p.107

Robot p.110

Friendly dog p.114

Adventurers p.108

Magical bus p.112

6 CHIBI

ちび/チビ

'Chibi' is an informal word used to describe someone who is small in stature, like a small child or a short person. It also implies a sense of cuteness. Within manga terminology, it's a style of drawing characters with childlike proportions.

CHIBI OVERVIEW

For Chibi characters, imagine you are converting an otherwise normal character into the proportions of a small child. The head takes up about one third of the height of the character, while the rest of the body is squished, rounded off at the edges, with chubby fingers and subtly shaped toes. Details like bones and knuckles are not shown.

It's important to remember some key rules, however. Facial features are simplified. The eyes are often drawn larger, and noses become dots or are left out altogether. The neck is very short, barely there. The body-to-leg ratio is still adult-sized: from the shoulders to the floor, legs take up at least half that height. Don't be tempted to draw legs too short.

Chibi is not one type of manga aimed at a particular audience, as featured in the other sections of this book. Rather, it is a proportion set you can use. You can find Chibi characters in Shounen, Shoujo and Kodomo manga primarily, and more rarely in Seinen or Josei manga. A series can be drawn entirely using this proportion set, or it can switch into Chibi just during comic moments.

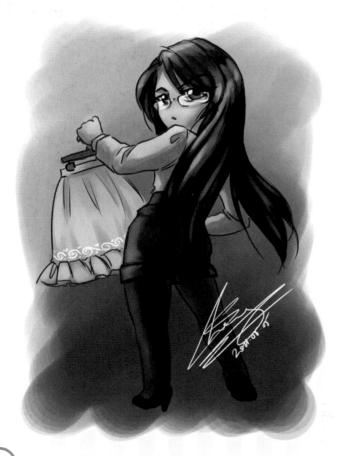

OPPOSITE TOP: *Although the tone of this story is introspective (the speech bubbles in the original featured the boy talking about souls), the characters are all drawn in Chibi style, with large hands and simple, stylised rendering.*

OPPOSITE BOTTOM LEFT: *The large, angled eyes of this fashionista give her a calculating look. Her hands and feet are small and delicate, but note how long her legs are compared to the rest of her body.*

OPPOSITE BOTTOM RIGHT: *This character is fashioned after a 'Maneki Neko', or 'beckoning cat' – a good luck figurine popular in Japanese businesses. These cats hold a coin and have one paw raised to beckon customers in. This character is an example of a 'Gijinka', a humanoid version of an animal or monster.*

RIGHT: *A digitally painted Chibi portrait, with warm colours and rough brushstrokes for a traditional feel. His stoic expression has been retained by simplifying his eyes and mouth into curved lines.*

BELOW RIGHT: *Chibi versions of real people use strong shapes and simplified details. The nurse is soft, with wavy curls and a flouncy dress. The catgirl is gangly and youthful, so the emphasis is on her oversized paws. The cool Visual Kei girl (a look that rolls Goth, punk and New Romantic into one) is angular and elegant, with straight, sleek hair in sharply defined layers and sharp clothes with pointed edges.*

DRAWING CHIBI-STYLE CHARACTERS

The concept of Chibi is a little different from the styles encountered so far. It is not so much one style aimed at a particular audience, but more a way of converting your characters into cute, mini versions of themselves. (See pages 140–141 for templates.)

Basic rules

Chibi means 'small child', so using childlike proportions for some aspects of your drawing is key, even if the character is an adult. Aim for a very low head-to-body ratio – three heads tall, or four at the most. Like a child, make your faces and heads rounder, noses smaller and eyes larger. Bodies become chubbier, and necks are much smaller and thinner. Round off all the hard edges and areas that usually stick out: shoulders, breasts, elbows, ankles. These body parts are smoothed over and simplified.

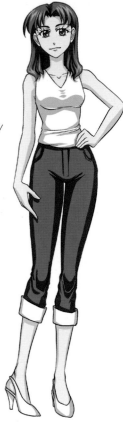

RIGHT: *An adult woman drawn with normal proportions. She is fairly tall and slim, at eight heads tall.*

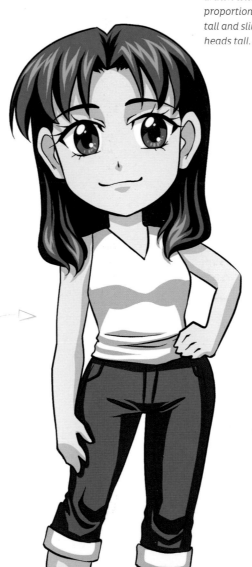

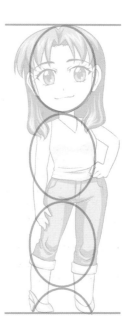

The woman's body shape

This uses the same pose as the regular adult figure (above right), but in Chibi form. She has been reduced to just over three heads tall. Her bumps and curves have been smoothed over, making her thicker overall. Her arms and legs still give the impression of length; they are still realistically sized, relative to her torso height. Her wrists and ankles, though, are chubbier like a toddler's.

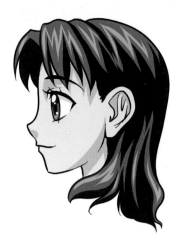

The man's body shape

When drawing a man as a Chibi, the challenge is getting the width of the shoulders and hips right. Shoulders should be narrow, but if they start looking narrower than the hips, it changes their masculine silhouette too much. When the neck is clearly visible like this, restrain yourself from drawing it too thick or long!

The woman's face

Like a young child, this woman's face is squished down and made rounder, with a restrained, snub-nosed profile. Her eyes are also very large in her face. But, you can differentiate between Chibi adults and children by getting the expression and hairstyle right. This woman's eye shape would be rounder if she was actually a child.

ABOVE: *An adult man drawn normally, at eight heads tall.*

The man's face

Like the woman above, everything but the eyes is squished down in height to make the face look more childlike overall. But, note the subtle differences when drawing a man: the profile of his forehead, nose, chin and jawline is more angular, so that even without the body for context, the head looks distinctly like an adult male drawn as a Chibi.

DRAW A CUTE SELF-PORTRAIT

Drawing yourself Chibi style is not just fun – it also gives you a little mascot version of yourself to use in comics or as an avatar. You can always take it further and draw your friends, too!

Photo source
Let's start with a photo portrait, and go through the process step by step.

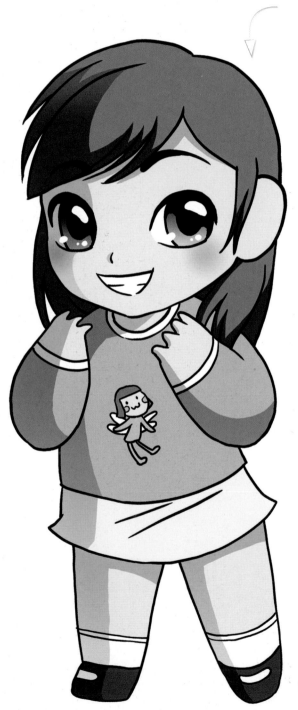

Final image

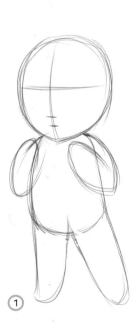

① Sketch your figure, focusing on the curves of the pose and the anatomy. (You'll find a template on page 141.)

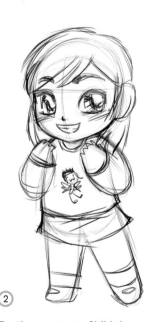

② For the most part, Chibis have very similar body shapes, so the face and clothing are the main identifying features. Pay particular attention to the eyes, expression and hair, so that you capture a likeness.

③

Try to keep the inking simple and clean. Chibis are most often simple in their rendering, so you don't need to ink any heavy black shading.

④

Now apply the base colours, matching them to those in the photograph – the hair, eyes and top. The skirt and shoes can then be coloured to complement the top.

⑤

To keep the aesthetic soft and cute, there are several gradients in the shading. See how it gets darker from the shoes up the leg, on the face from bottom to top, and on the hair from top to bottom. So while there is a solid, cel-style shaded edge to it, the gradients just give it a little more texture than traditional cel shading.

⑥

Finally, add a few finishing touches to the face. Shade her cheeks with a light blush. Then colour the eyes with a gradient to lighten the colour, and add some white highlights to really make them shine.

PRO TIP!
It's all in the eyes

The eyes are the windows to the soul – and with Chibis this can be especially true! As the eyes are so large, having them convey just the right mood or personality is essential to drawing a good likeness.

DRAWING EXAGGERATED FACIAL EXPRESSIONS

Chibis' exaggerated expressions add to their comedy and their charm. As Chibis are already very stylised, you have a lot more freedom to create overly dramatic, fun poses and situations with them. To start you off, here are a few select over-the-top expressions you can try drawing on your own creations.

Anxiety
This character is so nervous that sweat is pouring from her head. Her pupils are tiny and shaking, too.

Shock
Now, she looks almost haunted! She's so in shock that her eyes have transformed into unsteady little circles.

Bliss
Now, she is overjoyed. The thick eyelashes are central to this expression, as well as the dainty smile.

Sadness
Tears are now flowing down her cheeks. Her mouth is an upside-down V-shape, as she tries to stop herself from bawling out loud.

Anger
Here, she is so overcome with rage that her eyes are screwed shut, and she has a huge throbbing vein on top of her head.

Cunning
The combo of half-lidded eyes, peering sideways, and the cute cat mouth give her a calculating air (although she's probably not planning anything too terrible!).

PRO TIP!
Study your subject

**HELP!
I'M STUCK!**

Although really exaggerated expressions are fun, if you use them too often they lose their impact. Think about the personalities of the people you're drawing, and pick a couple of expressions that match their moods. You can even mix these expressions up a bit, and then customise them to particular characters.

DRAW YOURSELF AND A FRIEND WITH ANIMAL EARS

A very popular theme of Chibi illustrations is to add animal features to your characters for extra cuteness and personalisation. This is also known as 'Kemonomimi' in Japanese, which translates to 'beast ears'. You can add other animal parts, too, like tails and wings. Try drawing yourself and a friend as Kemonomimi . . . but choose your animal carefully!

(1) Let's try poses that reflect their personalities. The guy on the left is sunny and friendly, so although his back is to us, his pose is open. The one on the right is a bit grouchy, so he has been given folded arms and legs. (The template is on page 141.)

Photo source
Our two subjects are good friends, but they are quite different in looks and personality. Be sure to note the hairstyles, eyebrow shapes and clothing choices – these things can filter through even when drawing in a Chibi style.

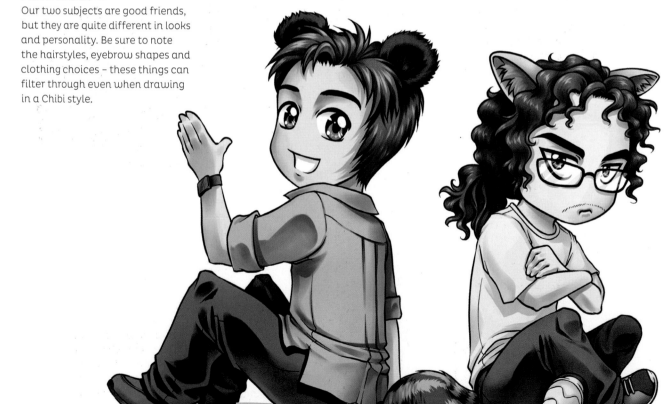

Final image

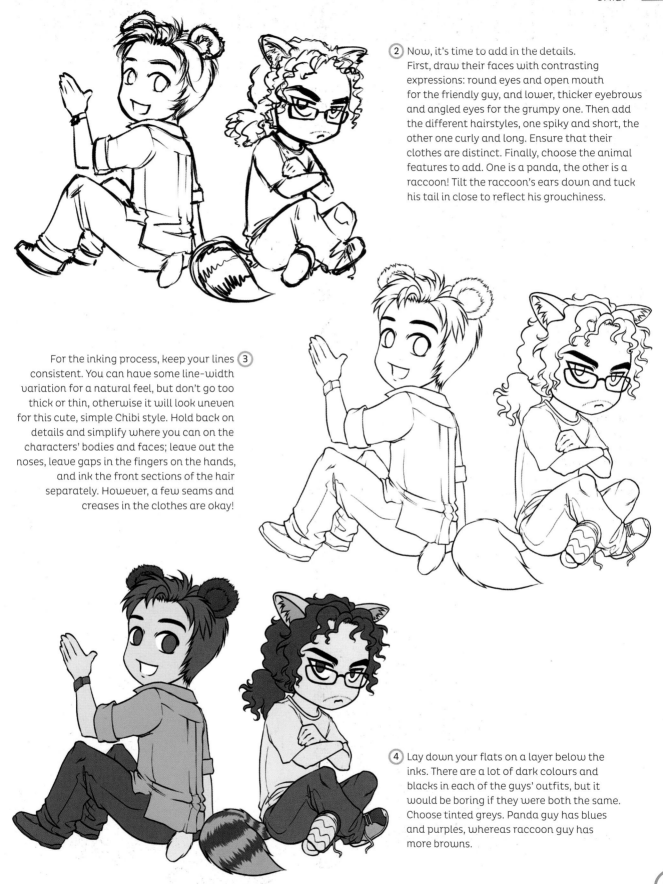

2 Now, it's time to add in the details. First, draw their faces with contrasting expressions: round eyes and open mouth for the friendly guy, and lower, thicker eyebrows and angled eyes for the grumpy one. Then add the different hairstyles, one spiky and short, the other one curly and long. Ensure that their clothes are distinct. Finally, choose the animal features to add. One is a panda, the other is a raccoon! Tilt the raccoon's ears down and tuck his tail in close to reflect his grouchiness.

For the inking process, keep your lines 3 consistent. You can have some line-width variation for a natural feel, but don't go too thick or thin, otherwise it will look uneven for this cute, simple Chibi style. Hold back on details and simplify where you can on the characters' bodies and faces; leave out the noses, leave gaps in the fingers on the hands, and ink the front sections of the hair separately. However, a few seams and creases in the clothes are okay!

4 Lay down your flats on a layer below the inks. There are a lot of dark colours and blacks in each of the guys' outfits, but it would be boring if they were both the same. Choose tinted greys. Panda guy has blues and purples, whereas raccoon guy has more browns.

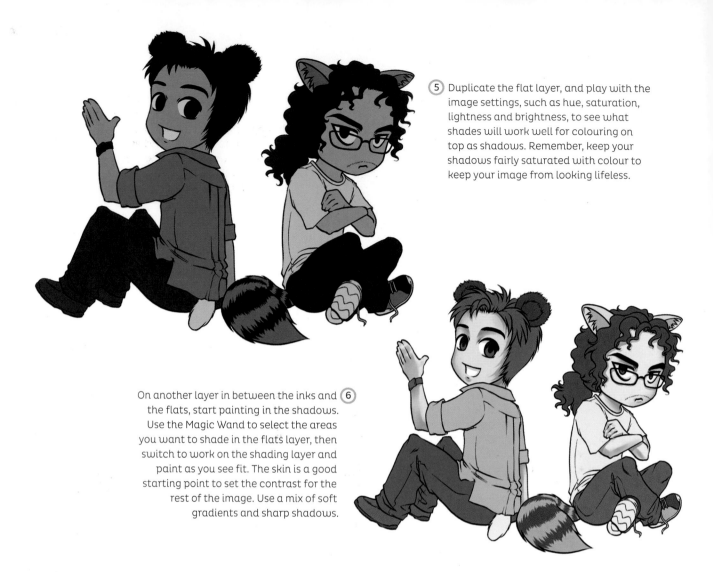

5 Duplicate the flat layer, and play with the image settings, such as hue, saturation, lightness and brightness, to see what shades will work well for colouring on top as shadows. Remember, keep your shadows fairly saturated with colour to keep your image from looking lifeless.

On another layer in between the inks and 6 the flats, start painting in the shadows. Use the Magic Wand to select the areas you want to shade in the flats layer, then switch to work on the shading layer and paint as you see fit. The skin is a good starting point to set the contrast for the rest of the image. Use a mix of soft gradients and sharp shadows.

PRO TIP!
Mixing soft and hard shadows

It can be quite difficult to shade in a soft style, so work in stages. Start with soft airbrushes or watercolour fills in the shadowed areas. This is particularly important for the curly hair on the raccoon guy; place dark washes below each bump in the curly waves.

Now, add sharp shadows to the darker areas and sharp highlights cutting into the dark washes for texture and more contrast. Don't lose sight of the overall shading of the hair, though; make sure that the general highlighted areas are consistent with the light source.

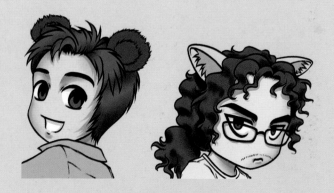

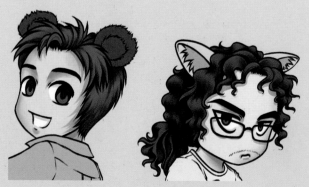

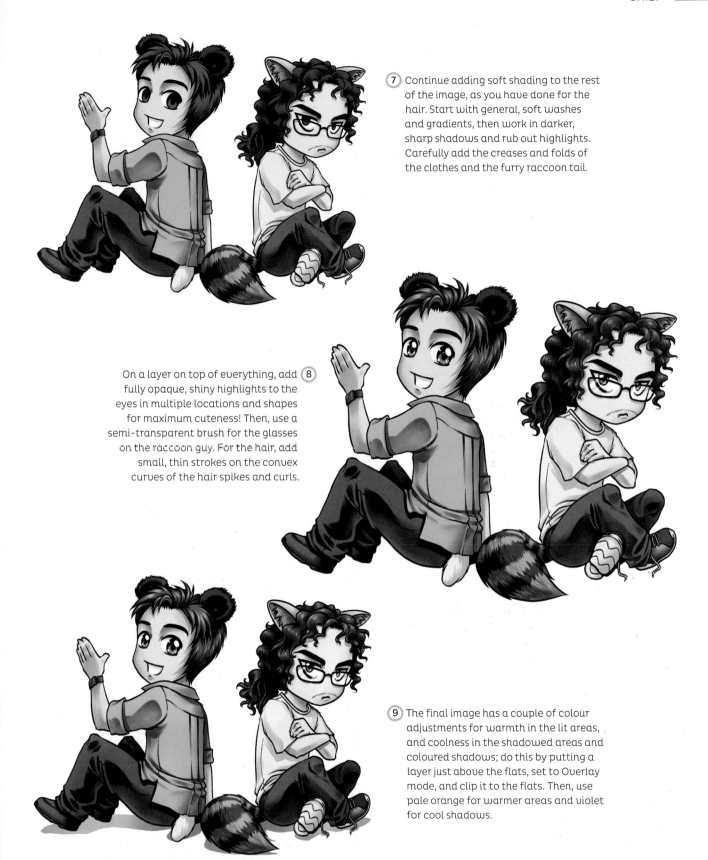

7 Continue adding soft shading to the rest of the image, as you have done for the hair. Start with general, soft washes and gradients, then work in darker, sharp shadows and rub out highlights. Carefully add the creases and folds of the clothes and the furry raccoon tail.

On a layer on top of everything, add 8 fully opaque, shiny highlights to the eyes in multiple locations and shapes for maximum cuteness! Then, use a semi-transparent brush for the glasses on the raccoon guy. For the hair, add small, thin strokes on the convex curves of the hair spikes and curls.

9 The final image has a couple of colour adjustments for warmth in the lit areas, and coolness in the shadowed areas and coloured shadows; do this by putting a layer just above the flats, set to Overlay mode, and clip it to the flats. Then, use pale orange for warmer areas and violet for cool shadows.

DRAW YOUR FOOD IN A CUTE STYLE

In Chibi manga, even food can have a personality. The drawing style has more of a Japanese design aesthetic – the sort of thing you might see as a mascot on packaging – so the colours are kept simple and the lines are thick.

Apple
The heart shape of this apple character is exaggerated, but it conforms to the ideal rather than the actual shape of a real apple. Having both a stem and a leaf are very decorative, too – especially when you're creating something very stylised. Sometimes drawing what people expect an object to look like, rather than what you might have in your reference photo, communicates the idea more effectively.

Photo source
Here we have a still-life photograph of a bowl of fruit, which we can use to create several different characters.

Cherries
Cherries almost always come in pairs, so these two are happily holding hands. It's the small things that give your designs personality; whether you're thinking about how a particular fruit grows or how it tastes, you can use these traits to help your designs.

Orange
This orange is super cheerful, with its big puffy red cheeks and huge smile. Note how, because it is stylised, the stem is drawn with a little star. You can use simple geometric shapes like this to add cute little touches to your designs.

Pineapple

A pineapple is one of the more complicated fruits to draw because of the pattern of its skin. Here, it's been simplified into a tiled geometric pattern.

As a general rule, food and other anthropomorphised inanimate objects look cutest when the face is placed around their widest part. You can see clearly how this works with these two triangles and a square.

Strawberry

Like the pineapple, the strawberry has a pattern on it. However, the pattern here is just to hint at the seeds, which would ordinarily cover the whole fruit. The placement of the seeds also helps balance out the position of the face.

Grapes

Grapes wouldn't be grapes if they weren't together in a huge bunch! Even as a bunch, though, they still all have individual expressions.

DRAW A COMIC STRIP: LOOKING AFTER A SMALL CHILD

Few things are as universally funny as some of the silly things children do to exasperate their parents. Many of these instances are so absurdly simple that they don't need much exposition. In fact, the best way to display these little incidents is by utilising 'Yonkoma', or four-panel comic strips. Western comic strips are typically three or so boxes in a row, but Japanese gag comics use four panels in a column.

1 Scripting

Yonkoma usually sets the scene in the first two panels before some conflict results in the punch line in the third or fourth panel. Keep dialogue short and sweet – you only have room to fit in four speech bubbles at most, and even then, these have to be short sentences.

1a: Here, a toddler is patiently emptying a bottle of milk into his father's suede shoes. Mum is lured into a false sense of security in the first panel. Her suspicions are aroused in the second, and she discovers the crime in the third. By the fourth panel you can see just how much spilt milk there was.

> **SCRIPT**
>
> *Lulled by a sense of calm, a busy mum sets to work.*
>
> MUM: *Finally, some peace and quiet so I can get some work done!*
>
> MUM: *A little too quiet …*
>
> *Discovering the baby in the hallway with a raised bottle.*
>
> MUM: *CHRIS!!! DROP THAT BOTTLE AT ONCE!*
>
> *Emptying the shoe, now filled with milk.*
>
> MUM: *EW … At least they're Daddy's shoes …*

2 Sketching

Chibi style is used almost exclusively in Yonkoma, and this story would appeal to both Josei and Seinen markets. Rather than going down the route of excessive detail and realism, it's better to keep it simple and stylised. You don't need to draw too much background either; keep the camera zoom tight. The emphasis should be on funny expressions and slapstick poses.

2a: Remember to keep those heads large and round, and keep the bodies softened and simplified – no hard edges. Start with Mum working peacefully at the table, then a close-up of her suspicious face. Cut to a panned-out shot of the baby and the bottle in the hallway, then finish up with Mum emptying the shoe with a disgusted expression.

3 Inking

The look and feel of the comic should match the whimsy and charm of the story. The traditional crisp, black lines and dot screentone of most manga is a bit too black and white (excuse the pun), so the inking here is soft, fading in and out, with lots of gaps to hint at rounded volume and highlights. The lines are also very minimal, to keep with the simple style.

3a: Whether you choose to ink with traditional materials or digital tools, always remember that the inks are what will be seen in the final product. The traditional method is to ink over pencils that you can erase or filter out in the printing/copying process. If inking digitally, reduce the opacity of the sketch and do your inks on a new layer on top.

3b: For a softer look than traditional manga, ink in dark grey with a marker pen that has a brush tip. As you ease off the pressure, the lines will both taper off and become lighter.

4 Speech bubbles

Placing and inking speech bubble outlines in Yonkoma is an organic process, due to limited space. Be prepared to move the bubbles to fit around the character artwork and vice versa. If your characters are well away from the dialogue, inking them later is fine, but if the bubbles partially obscure the main image in the panel, then it's better to ink the bubble first. Make the style appropriate to the type of dialogue, too – soft and less defined for thoughts, spiky for shouts, and rounded with a small tail for normal speech. Use the same pen as before.

4a: As the first two panels are thoughts, the outlines are indistinct – a few swirls with lots of gaps. The third panel is a shout, broken into two groups of spiky bubbles. The final dialogue is a softly spoken aside, again split into two groups, with a simplistic single line tail.

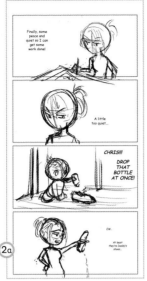

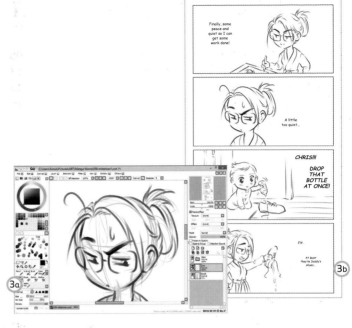

⑤ Shading

As befits the cute and whimsical line art, the shading should be kept very simple and soft, like pastel or watercolour fills with only subtle gradients to define highlights and big contrasts in colour. But, don't be fooled into thinking that allows you to get away with making a large, grey, muddy mess. Maintain a good variation in contrast by using very light and very dark shades on hair and clothing, particularly if they are adjacent. Ensure there is a good visual contrast from one panel to the next so that the finished strip looks interesting as a whole.

5a: Using soft grey washes to shade the simple line work makes the overall strip look very charming. Err on the side of using less, rather than more; keep the shading within the lines so that it doesn't look too messy. Light shades work nicely as fills, but darker shades work best with a highlight, such as leaving white areas in the dark hair.

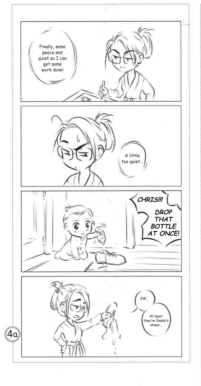
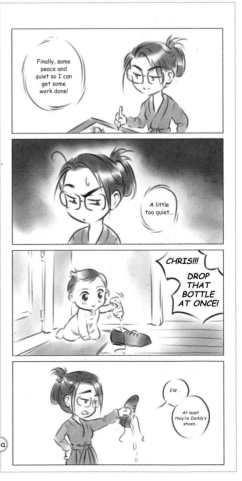

CHIBI FIGURE TEMPLATES

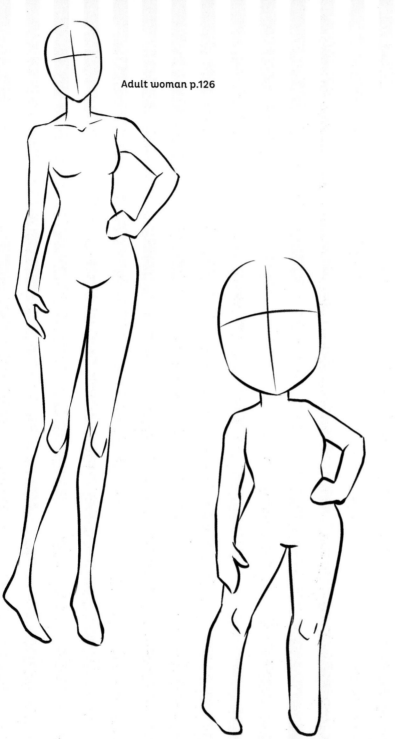

Adult woman p.126

Adult woman in Chibi form p.126

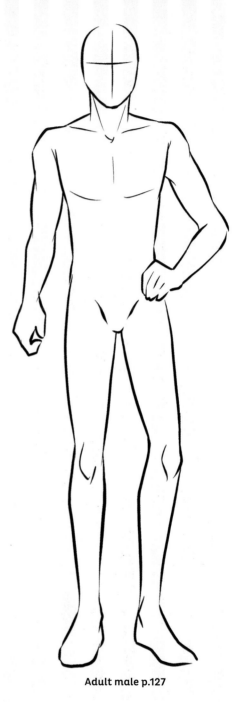

Adult male p.127

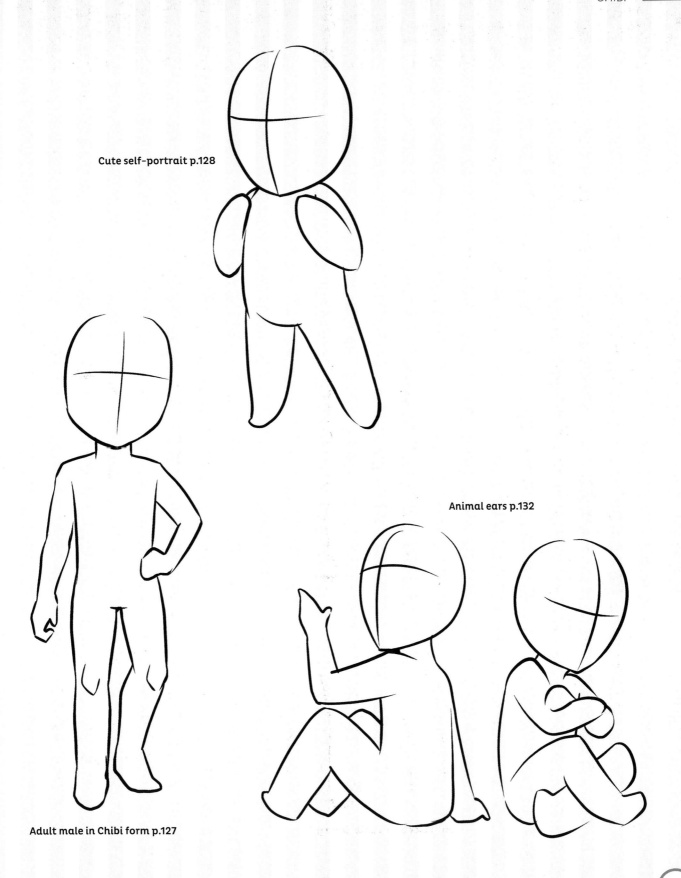

Cute self-portrait p.128

Animal ears p.132

Adult male in Chibi form p.127

INDEX

A

accent colours 95
action line 15
airbrushing 13, 21, 68, 75, 93, 134
aloof senior 33
anatomy 16
animal eyes 117
animals 107, 112–117, 121, 132–135
anthropomorphism 136–137

B

babies 138–139
backgrounds 21, 49, 53, 57, 73, 78–80, 97
bad boy 53
best friend 32
blurring 92
body proportions 15–16, 18, 32–33 106, 124–127
body types 15–16, 30, 32–33, 50, 68, 88, 106, 126–127
boys 106–109
bride and groom 49

C

'camera' angles 42
cars 76–77
cats 125
cel art 13, 37, 57
Chibi 122–141
Chibi figure templates 140–141
Chibi style 124–125, 126–131, 133, 138–139
child figures 16
children 16, 102–111, 118–119, 138–139
clothing 15–16, 19–20, 30–33, 35, 37, 41, 50, 52, 57, 59, 68–69 71, 75, 81, 86–88, 90–91, 95–96, 106–107
clothing patterns 20, 59
coloured pencils 10
colouring 12, 19–21, 35, 37, 39, 55, 59, 73, 75, 77, 93, 95–97, 109, 111, 116–117, 129, 133, 134
comic strips 42–43, 60–61, 78–81, 98–99, 118–119, 138–139
computers 12–13
couples 49, 56–57, 58–59, 89, 98–99
curly hair 20, 55

D

demons 78–81
diagonal gutters 24
digital painting 19, 75, 97
digital screentone 13
digital tools 12–13, 19–21, 73, 75, 134
dogs 107, 112–117
drawing basics 14–17

E

ears 132–135
eyes 53, 58, 95, 111, 117, 129

F

faces 14, 31–33, 51, 69, 89, 107, 127, 137
facial expressions 41, 69, 89, 130–131, 133
facial features 14
fairy-tale princess 96–97
fantasy characters 34–37, 45, 66, 96–97, 112–113
fashion 54–55, 81, 86–88, 90–93, 125
female Chibi characters 124–126
female clothing 20, 32–33, 50, 54–55, 57, 59, 69, 75, 86–88, 90–93, 95–96, 107
female Josei characters 86–89, 94–97
female Kodomo characters 106–109
female Shoujo characters 50–51, 53–55
female Seinen characters 69, 74–75
female Shoujo characters 50–51, 53–55
female Shounen characters 29, 32–33
femme fatale 74–75
fighters 29, 70–71, 87
figure drawing 15, 16, 18
figure templates 44–45, 62–63, 82–83, 100–101, 120–121, 140–141
fingers and thumbs 17
flames 38–39, 72–73
flowers 51, 53
football 105
foreshortening 29, 31, 87
fruit 136–137

G

geisha 94–95, 101
Gijinka 125
girl next door 32
girls 105–109
glasses 57
golfer 40–41
Gothic Lolita 54–55, 90–93
grey tones 41
grisaille shading 77
gutters 23–25

H

hair 20, 31, 33, 55, 105, 107, 134
hands 17
Harajuku 54–55, 63
hatching 53, 66–68, 78, 80
heads 14, 16, 69
highlights 37, 53, 57, 69, 77, 134–135
historical subjects 70–71, 94–95
horror 78–81

I

ink and inking 11, 19, 39, 41–42, 50, 57, 60, 68, 73, 75, 92, 97–98, 129, 133, 138

J

Japanese reading direction 22
Jidaigeki 70–71
Josei 84–101
Josei figure templates 100–101
Josei narratives 86, 98–99
Josei protagonists 88–89
Josei style 86–87, 92–93, 95, 98

K

Kemonomimi 132–135
kimonos 71, 95
Kodomo 102–121
Kodomo animals 112–117
Kodomo figure templates 120–121
Kodomo narratives 104–105, 118–119
Kodomo protagonists 106–109

Kodomo supporting characters 107
Kodomo style 104–106, 118

L
Layer Settings 73
layering colour and shading 12, 19, 21, 41, 73, 75, 77
lighting 20, 42, 93

M
magic transport 112–113
Magic Wand 20, 134
male Chibi characters 124–125, 127, 132–135
male clothing 30, 35, 37, 41, 52, 57, 68, 71
male Josei characters 89
male Kodomo characters 105, 106–107, 108–111
male Seinen characters 68–73
male Shoujou characters 52
male Shounen characters 30–32, 34–41
Maneki Neko 125
markers 12, 39, 138
mecha pilot 36–37
mecha robot 36–37
media 10–13
mother 107, 138–139
motion 40–41, 51, 78, 80, 92

N
narration panels 23
night scenes 42–43
nurse 125

P
paint and painting 12–13, 19, 55, 59, 71, 97, 105, 134
panda 132–135
panel break-outs 25
panel layout 22–25, 41, 61, 79–81, 99, 119, 139
panel overlaps 25
panel size 24
panels fading in/out 24
paper 10–12
pencil guidelines 10, 18–19, 71
pencils 10
pen and ink 10–11
pen stylus 13
pen techniques 11, 19, 39, 73, 75, 92, 138
pets 107, 114–117
photo sources 7, 14–15, 18–21, 76–77, 90, 114–115
poses 31, 35, 37, 51, 54, 91, 96, 116
printing 11
profiles 31, 51, 69, 89, 127

R
raccoon 132–135
reading direction 22
realism 66–68
rival girl 53
robots 36–37, 110–111, 121
romance 49, 56–59, 89, 98–99

S
samurai 70–71, 83, 105
school uniform 56–57
schoolgirls 29, 56–57
science fiction 36–37
screentone 11, 41, 42, 60, 71, 80, 98, 118
scripts 42, 60, 78, 98, 118, 138

Seinen 64–83
Seinen figure templates 82–83
Seinen narratives 66–67, 78–79
Seinen protagonists 68–69
Seinen style 66–67, 80
self-portraits 90–93, 128–129
Sempai 33
sequins 75
shading 13, 20, 35, 37, 39, 41, 55, 77, 93, 113, 129, 134–135, 139
Shoujo 46–63
Shoujo figure templates 62–63
Shoujo narratives 48, 60–61
Shoujo style 48–49
Shoujo protagonists 50–51
Shoujo supporting characters 52–53
Shounen 26–45
Shounen figure templates 44–45
Shounen narratives 28–29, 42–43
Shounen protagonists 30–31
Shounen supporting characters 32–33
Shounen style 28–30
shouting 23
skateboarder 31
skin 20, 41
sorceror 34–35
speech bubbles 23, 42, 98, 138
spiky hair 31, 33, 39
sport 38–41, 45, 105

storyboarding 22–25, 28–29, 42, 60–61, 98, 118, 138
straight hair 20
street scenes 79
student 52
supernatural characters 34–35, 38–39, 72–73, 78–81, 83

T
teenage boys 28–33, 38–39, 42–43, 52, 56–57
teenage girls 29, 32–33, 50–51, 53–57, 60–61
thinking 23
tone of voice 23
tracing 76
traditional tools 10–11
trees 21, 79

W
watercolours 12, 50, 105, 134
weapons 29, 70–71, 79–81, 109
wedding 49
whispering 23

Y
Yonkoma 118, 138–139

PICTURE CREDITS

Illustrations:

Sonia Leong (all illustrations unless otherwise stated), Selina Dean p.102–105, 108–113, 118–119, 124 (t and br), 128–131, 136–137; Shazleen Khan p.67 (tr), p.86 (r); Philip Knott p.67 (tl); Michael Oliveras p.29 (tl).

Photographs:

p.4 (tl) photography Small Stories Photography, models Nicole Kemble and Sophie Briault; (tr) photography and model Sonia Leong; (bl) iStock; p.5 (tr) photography Tamsin Richardson; p.7 (tl, tc) Getty; p.11 (br) photography Agata Rybicka, model Tamsin Richardson; p.14-15 photography and model Sonia Leong; p.16 (tr) photography Sonia Leong, model Kris Bentham; p.17 photography and model Sonia Leong; p.18 (bl) iStock; p.32 (l) Getty; p.33 (bl) Corbis; p.34 (tr) photography Tom Garnett, model Alex Locke; p.36 (tr) photography Sonia Leong, model Matthew Bentham; p.38 (tr) photography Sonia Leong, model Kay Corey; p.40 photography Allen Henry, model Sujjan Singh; p.50 (tr) Corbis; p.52 (l) Getty; p.53 (tl) Getty; p.67 (br) Corbis; p.70 (c) Corbis; p.74 (bl) photography Nicola Jackson, model Louise Strong; p.76 (cl) Corbis; p.87 (t) Corbis; p.88 (tr) Getty; p.89 (c) Corbis; p. 90 (bl) photography Sonia Leong; p.94 (tr, c) iStock; p.105 (c) Getty; p.106 (bl, tr) Corbis; p.107 (c) Corbis; p.108 (r) photography Mark Searle, models Romilly Searle and Laurie Searle; p.110 (l) photography Small Stories Photography, model Luca Briault; p.112 (tl) photography Mark Hudson; p.125 (tr) photography and model Seth Leong; p.126 (bl) Getty; p.127 (bc) Getty; p.128 (tr) Corbis; p.132 (tl) photography Sonia Leong, models Simon Leong, Alasdair Poon.